FIFTY MILES FROM

Home

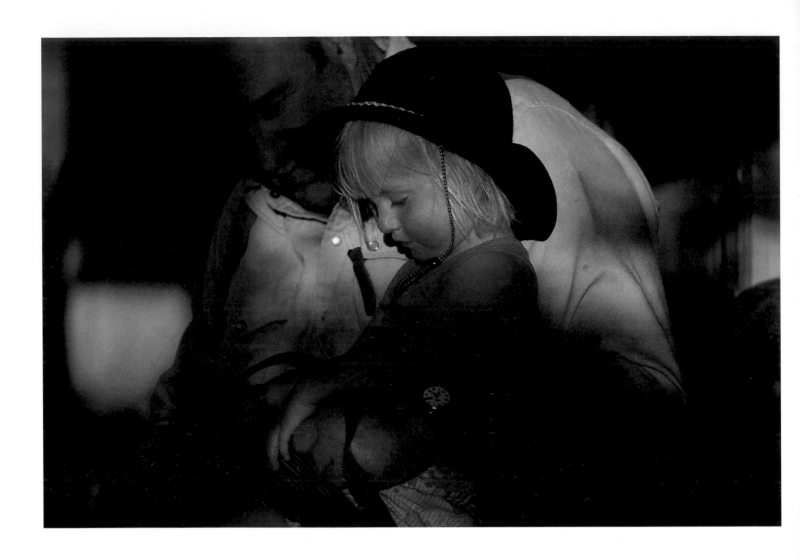

FIFTY MILES FROM
Home

Riding the Long Circle on a Nevada Family Ranch

PHOTOGRAPHS BY Linda Dufurrena
TEXT BY Carolyn Dufurrena

UNIVERSITY OF NEVADA PRESS / RENO & LAS VEGAS

University of Nevada Press, Reno, Nevada 89557 USA

Photographs copyright © 2002 by Linda Dufurrena

Text copyright © 2002 Carolyn Dufurrena

Manufactured in China

Design by Carrie House

Map by Christopher L. Brest

Library of Congress Cataloging-in-Publication Data

Dufurrena, Linda, 1937–

Fifty miles from home : riding the Long Circle on a Nevada

family ranch / photographs by Linda Dufurrena ; text by

Carolyn Dufurrena.

p. cm.

ISBN 0-87417-443-0 (hardcover : alk. paper)

1. Humboldt County (Nev.)—Pictorial works. 2. Santa Rosa

Range (Nev.)—Pictorial works. 3. Ranch life—Nevada—

Humboldt County—Pictorial works 4. Humboldt County

(Nev.)—Description and travel. 5. Santa Rosa Range (Nev.)—

Description and travel. 6. Ranch life—Nevada—Humboldt

County. 7. Dufurrena, Linda, 1937– . 8. Ranchers—Nevada—

Humboldt County—Biography. I. Title: 50 miles from home.

II. Dufurrena, Carolyn, 1953– . III. Title.

F847.H8 D84 2001

979.3'54—dc21 2001001517

The paper used in this book meets the requirements of American
National Standard for Information Sciences—Permanence of
Paper for Printed Library Materials, ANSI z39.48-1984.
Binding materials were selected for strength and durability.

11 10 09 08 07 06 05 04 5 4 3

Frontispiece: Buster Dufurrena and his granddaughter, Magen
Dufurrena, at the home ranch.

This book was funded in part by

grants from the Nevada Humanities

Committee, a state program of the

National Endowment for the

Humanities; the Charles Redd

Center for Western Studies at

Brigham Young University; the

Heritage Bank of Nevada; and the

John Ben Snow Memorial Trust.

For Jan Cayot, whose circle is complete

Since the first explorers set foot in the American West they have recorded the wonders they saw in letters, books, symphonies, paintings, sculptures, and churches.

Linda and Carolyn Dufurrena are members of a family that have lived in Nevada for generations. They are well qualified to tell their story of the rural West. There is menace in their black mountain, serenity in the band of sheep herded toward their evening bed–ground, and heartbreak in their loving portrait of the little buckaroo who will grow up and leave.

No one who has not lived the life through good times and bad would have taken the funny picture of three cowboys swimming, nor caught the tenderness of the herder carrying two leppy lambs, or known the lush beauty of Dayton Creek's banks.

Linda's photographs and Carolyn's essay remember a time that is fast disappearing.

—MOLLY FLAGG KNUDTSEN

When a buckaroo crew gathers a piece of country, whether it is canyon, ridgeline, or sagebrush flat, there is one person who takes the long circle, the outside circle. It is usually the boss, but it is always the person with the responsibility for making sure everything is gathered that can be gathered, and it is the person who will see what work needs to be done the next day. He stands on the highest ridge, where he can see the farthest, to keep track of the riders below, to gather the images in his sight of the sweeping arc they make through the countryside, sometimes miles away.

This book is a gathering in of the scenes that build our lives, of the stories that inform the images. We can see from here the stories that have been told, and those that remain to be told— images yet to be captured. Some stories can never be shared, because their time is gone. Like the gather of animals across the space between us, there are escapees. It is not always possible to follow the cow-boss' directive: "Bring everything." But we have tried to bring what we could, and as for what is still out there, that is another circle.

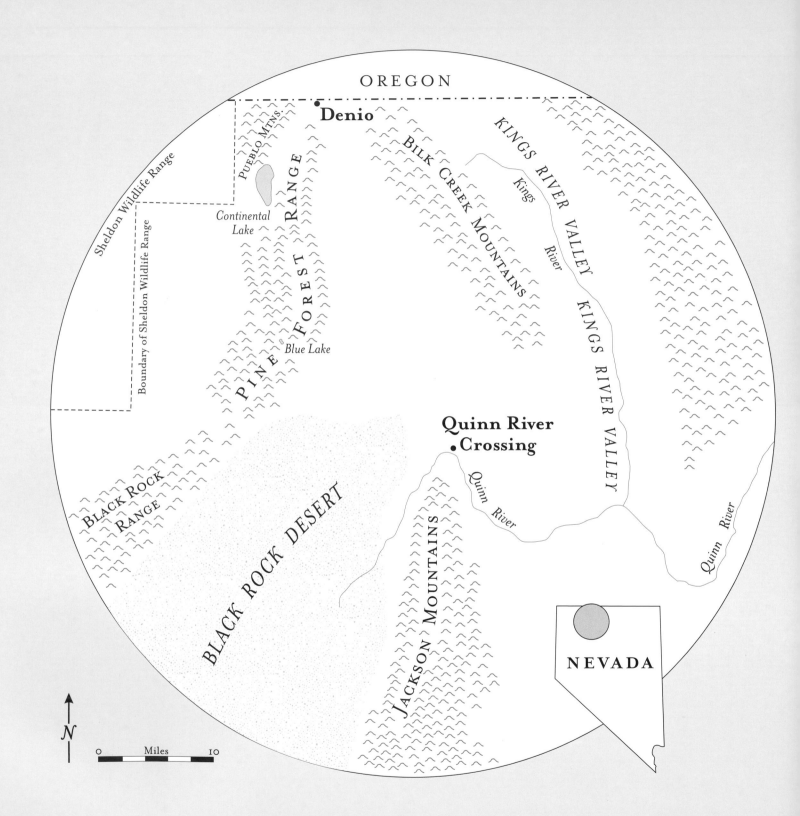

OREGON

Denio

Sheldon Wildlife Range

Boundary of Sheldon Wildlife Range

PUEBLO MTNS.

Continental
Lake

PINE FOREST RANGE

Blue Lake

BILK CREEK MOUNTAINS

KINGS RIVER VALLEY

Kings

River

KINGS RIVER VALLEY

Quinn River
Crossing

Quinn River

Quinn River

BLACK ROCK RANGE

BLACK ROCK DESERT

JACKSON MOUNTAINS

NEVADA

N

0 Miles 10

CONTENTS

ILLUSTRATIONS

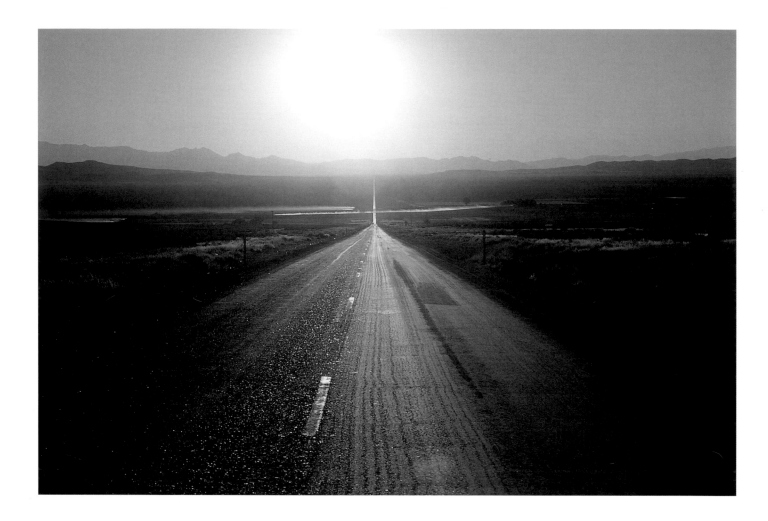

Golden Highway 140

The first time I saw that thin strip of highway stretch down the fan of the Santa Rosas, I was twenty-five years old, a geologist full of my own independence, intoxicated by the freedom and the emptiness of the desert after years in Eastern cities. Still, this junction of highways, this turn in my path, stopped me cold for some moments. I pulled over.

That day there was dust in the air, the light diffusing shades of gold and yellow. The road disappeared into the distance of the late afternoon across the wide valley, between two ranges sinking into sediment. Another great expanse of valley was barely visible beyond that, backed by more dark ridges. There are afternoons when storms rage across that emptiness and do not fill its vastness. Light suffuses rain or snow or dust or smoke of lightning fires. It seems like the entrance to another world, a world in which a storm can be visibly contained within a space, in which quirks of topography and air mass, humidity and temperature, interact as though on a stage. Then I feel small—and large—part of the storm, part of the dust, part of the cradling ranges that promise something greater than the storm. It is a world in which the outrageous visions of painters like Bierstadt seem more documentary than romance. I have driven this stretch of empty country a thousand times since that first day, and I am still seduced by it.

—CAROLYN DUFURRENA

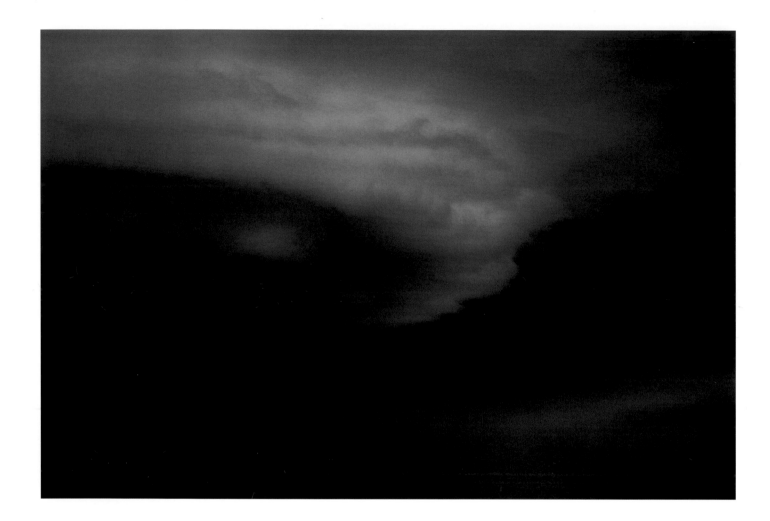

Dramatic Storm Clouds

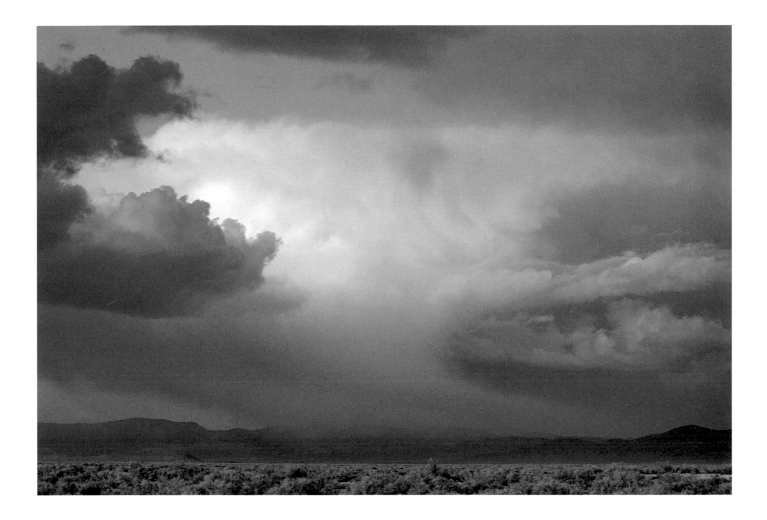

Desert Storm Off Highway 140

It has taken me some time in my photographic career to realize that what I see close to home is as unique and special as any place in some romantic faraway land. There are images I remember clearly of the young cowboys saddling up before dawn and riding up the dirt road at Wilder Creek, or of the last Basque sheepherders from Spain tending the sheep at Lovely Valley sheep camp, or of the many farmhands I cooked for at the Quinn River Crossing Ranch cookhouse. It was years before I picked up a camera. Those images are all still in my mind, but that is the only place they are recorded. These were images of a time that was passing, images that would never appear again. Sometimes I think I have photographs of them all, but of course I do not.

I am pleased to share these images of our extended ranch family, my three sons, their families, our friends and neighbors, the animals, and the many moods of the landscape of which I am a part. They were all taken close to home, within a fifty-mile circle. Everything I need is right here.

—LINDA DUFURRENA

ACKNOWLEDGMENTS

Barry Bradford, Louie and Frank Bidart, Merv Takacs deserve
special thanks. Frank Dendary, Marcos Gortari, and Pete Salla
helped us with this work and told us stories that inspired us.
Raymond Dufurrena and Marguerite Dufurrena Stephen
brought the history of the Sheldon Wildlife Refuge to us in a
new way. Jay Marden provided lively discussions and newspaper
reports from the *Humboldt Register*. Jim Jeffress of the Nevada De-
partment of Wildlife gave Carolyn the helicopter ride that started
her thinking about our place in space and time. Fred Utter of
the University of Washington and Jim French of the Nevada De-
partment of Wildlife contributed information on how to tell one
species of trout from another. Evan C. Evans explained the trav-
eling of sound and light through the desert in a way that made
physics magic. Thank you all. And of course, the support and
encouragement of our family makes this work possible.

FIFTY MILES FROM
Home

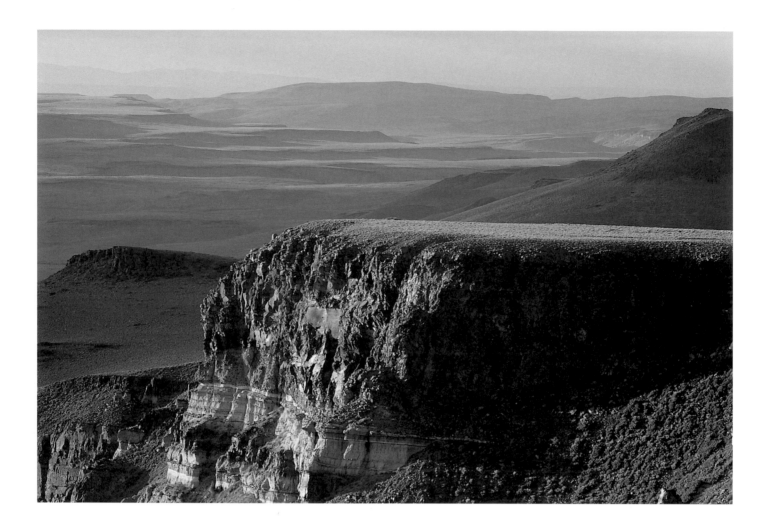

Mesas to the North of Summit Lake Mountain

Sometimes,

on the right kind of morning, Nevada looks like waves frozen in rock.
Long ridges roll away to the horizon. Broad stretches of sage and
playa form paler troughs between them. From a distance, it all
looks barren, lifeless, baking. But within it hide riches for the
senses and the spirit.

Just on the cusp of summer, we have ridden into a rocky,
snake-infested, beautiful green crease in the shoulder of a granite
mountain. Mountain mahogany and snowberry fill the draw up
high. Six-foot water hemlocks spread their deceptively lovely
leaves below the meadow of the canyon homestead we call the
Dutchman. We are gathering cows to move them to the high
country. I'm coming down the bottom of the canyon. My husband,
Tim, is on the ridge above me, somewhere.

I hear something, look up. He's waving me back, the way I
came. I twist around, scanning the slope, but the hillside is clean.
I start up the right fork of the draw, hear more hollering. He's
waving his hat in frustration now. Tentatively, I turn my horse the
other way. Across the blue space between us floats this fragment:
" . . . above you! Behind you on the hill!"

It's a steep, rocky slope, rising four hundred feet in a quarter
mile. My horse scrambles and huffs; we switchback up the

3

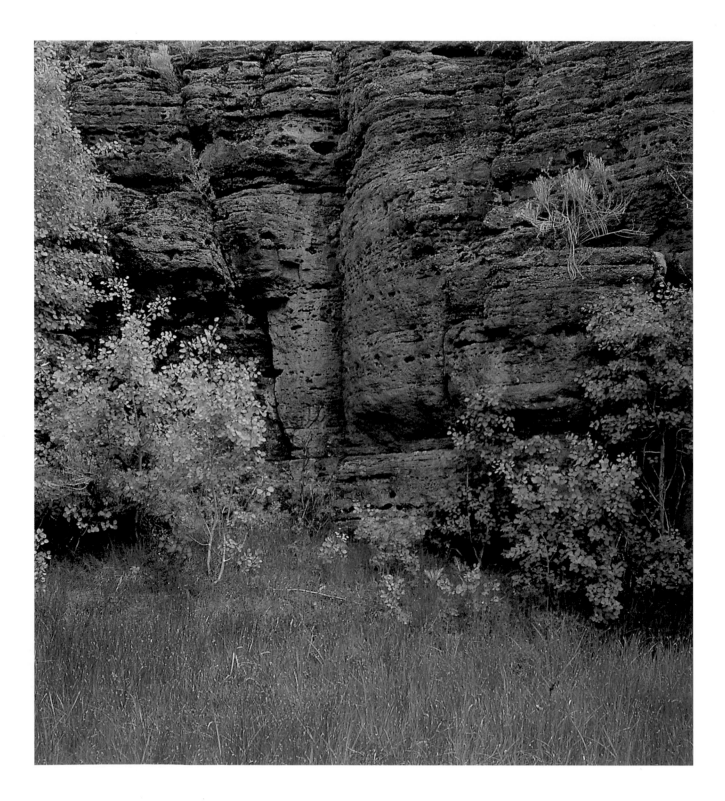

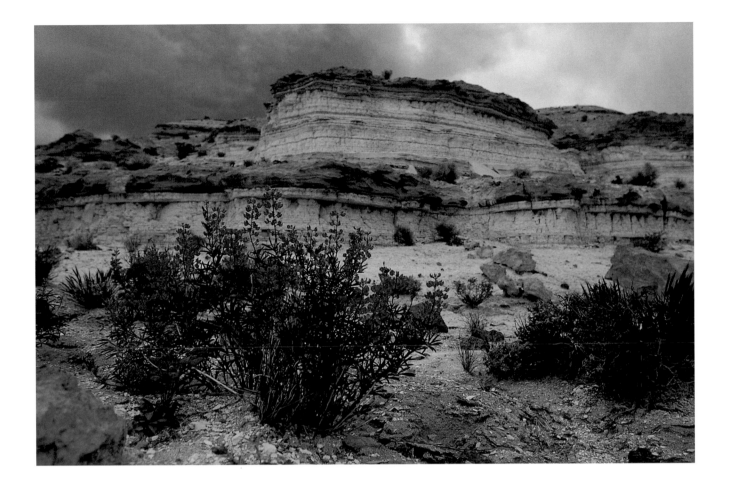

(facing page) *Hidden Meadow;* (above) *White Cliffs and Lupines*

sidehill. Around the back, way on top, one red-horned cow pokes her white face out of a thick patch of mahogany. One whoop and she's obediently down the canyon. I lose sight of her, pick my way off the hill, through the boggy meadow below, up the other side. He only says, "If I tell you to go back, it's because I can see something you can't." We trot just a little further, over a saddle, and below me spreads a whole world.

From the nameless ridge between two canyons where I sit, my eye scans perhaps three hundred miles. Our home place is on the valley floor thirty miles to the south, wavering in the heat. Its shade makes a square shadow of darker green in lighter green alfalfa fields. To the east big volcanic ridges march off to the skyline, broken by occasional faults, punctuated by masses of granite poking through the ash flow blanket. To the north, the terminus of the range has torqued itself to breaking. It is a wrenching motion, legible on satellite image, and in the quartz veins that have healed the open fractures in the rock. The broken spine of the mountain curves off to the north, the tailbone of a fallen giant half submerged in alkali mud.

Westward through this pass, across the border into Oregon, flat basalt tables step off like black platters into the distance. Over there, there are no more huge waves of rock. An immense regional fault transforms the motion of the earth's crust from up and down to a hidden sideslipping. In a few miles, the entire terrain changes. We humans appear more important in a flat country, where we cannot see the true scope of our world.

You must climb up to a high place, to see what you cannot see from below. People who spend time in the Basin and Range know this; their perspective on their lives differs because of it. There is

6

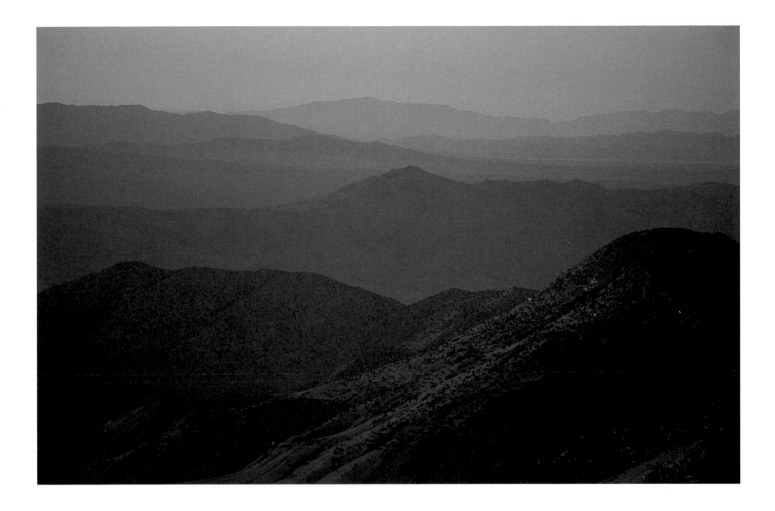

Mountains of Blue

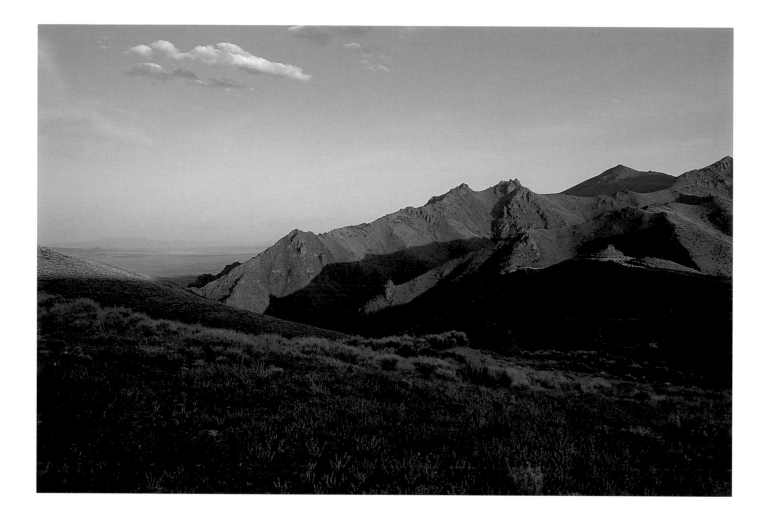

8 *Head of Bottle Creek*

Bilk Creek Point

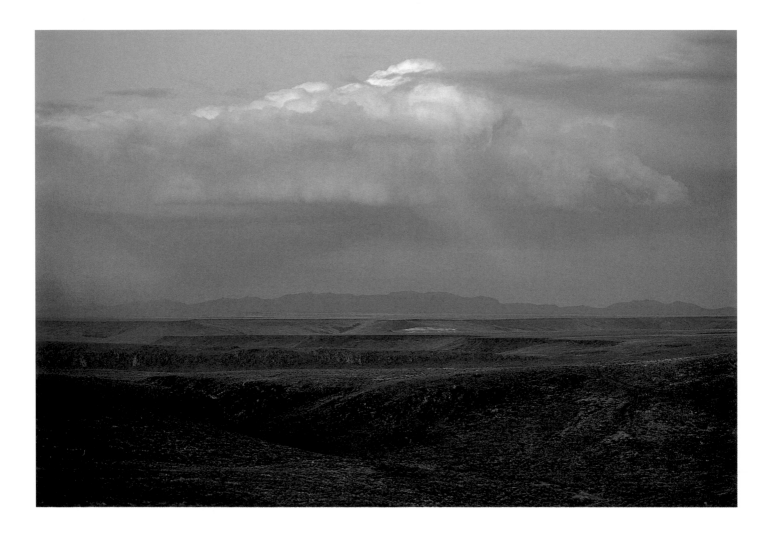

Gooch Table

less opportunity for this lesson in other, less violent and barren places. This difficult country is always ready to teach, if you can be silent, wait for the lesson. The huge emptiness of the desert puts all human activity, all human emotion, into perspective: the work we do, the generations of family, which hold our place in time. One has only to sit for a while on a crest of one of these frozen waves to realize how tiny that place in time and space truly is.

※

Once, a helicopter crew stopped at our ranch, counting deer in winter. The January pogonip, the ice fog peculiar to the desert, had blanketed the valley for weeks. The whole world was gray, no mountains visible. The definition of the land was gone. We moved through our days by instinct, knowing the tasks, unable to see our destination. The wildlife biologist offered a ride, an opportunity to help with the winter count. I jumped at the chance.

The helicopter took off heavily. At first we skimmed the valley floor, spotting herds of mule deer, pushing and scattering them like leaves below us, counting does and fawns, the year's crop. We rose to fly along the ridges, spotting the darker shapes moving through the snow-covered canyons. We rose blindly through hundreds of feet of nothingness, seeing only droplets of cloud on the chopper's plastic bubble. Finally, a blinding beam speared the fog. After weeks of monotony, a clear pink sky. We skimmed the peaks, strings of blue islands in a sea of brilliant white, the air crystalline. I thought of the people not so far below us on the valley floor, moving through the sea of gray. If you shift your center, your world appears completely changed.

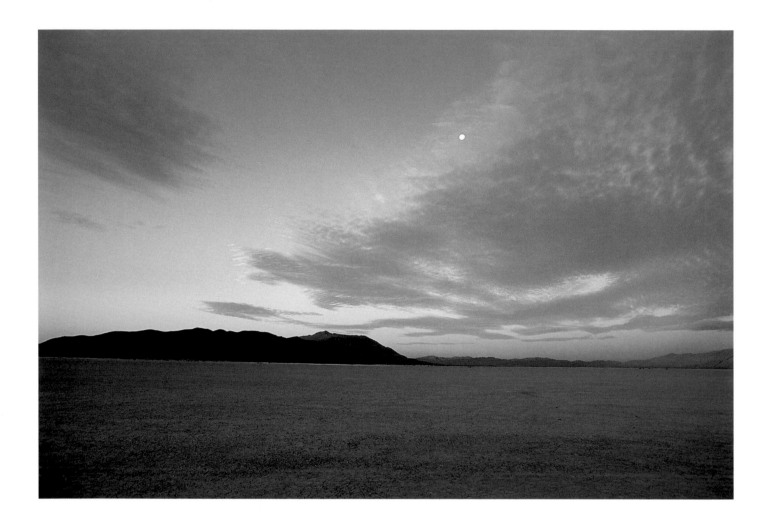

Dawn on the Black Rock Desert

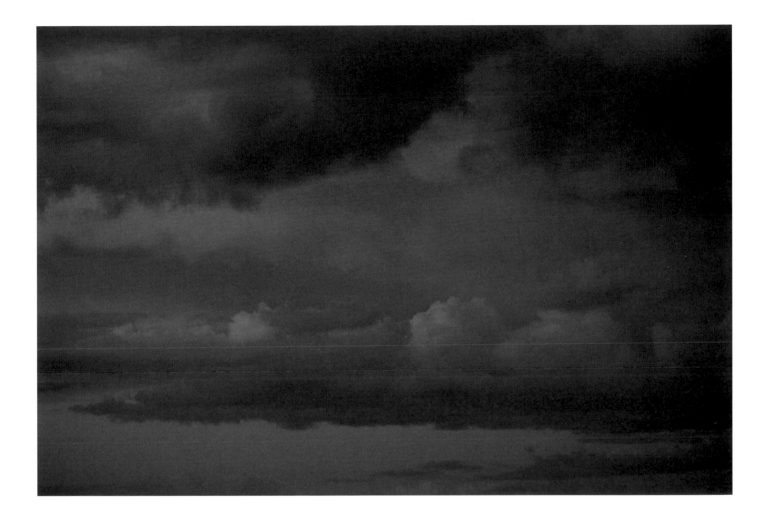

13 *Pink Clouds*

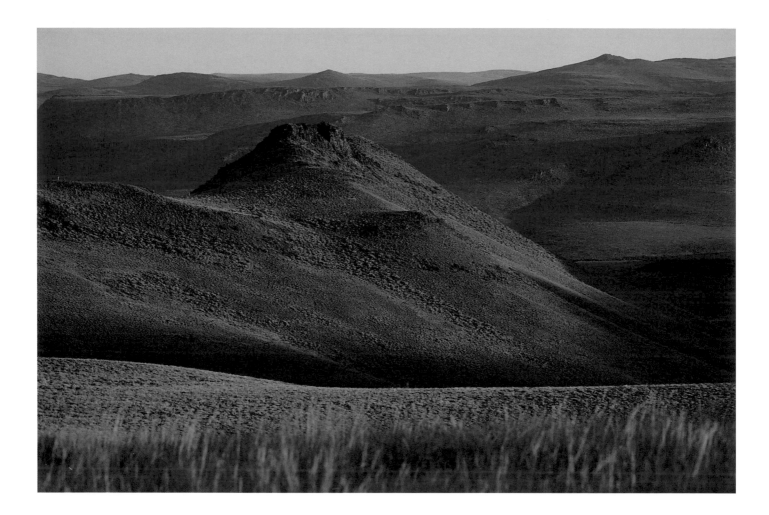

14 *Velvet Hills*, Summit Lake Mountain

We can scribe a circle, an area of influence, let us say, around our home. Fifty miles. It's a long way, and yet in the desert not so long. Fifty miles from home, if home is the center of our circle, you can sit on a barren peak, the schussing of wind through short, high-altitude grasses the only sound. Hide in a cool cave beneath that peak and let your eyes stretch the length of the blinding summer playa. Follow the rhythms of life on the ranch, along the base of mountains in winter, into the foothills and the big, cool basins of summer, where people and animals find shelter under the aspen. Run your fingers along the rough edges of shapes carved by lonely men from another land, names, dates, the curving form of a woman's hip echoing the silver curve of an aspen trunk. *I was here, alone, a long time ago.* Follow the rhythms of the people who live this life now, families, neighbors; watch that life changing, the old ways going. There are still ranching families who pass the old skills to their grandchildren, but they are fewer each year.

This book is a collection of images, in photographs and in words, of the country in our circle, of the places where we do our work and raise our children. Of the people who teach us about the place we live, and about each other.

There is no richer world than here,
 just fifty miles from home.

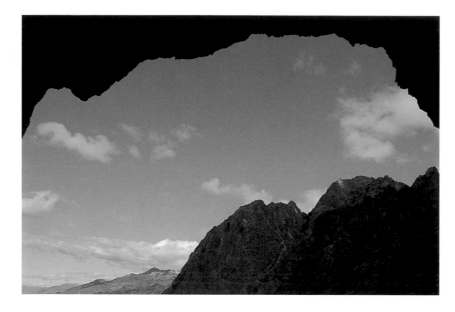

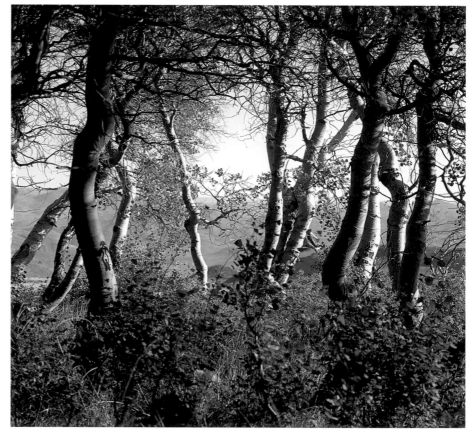

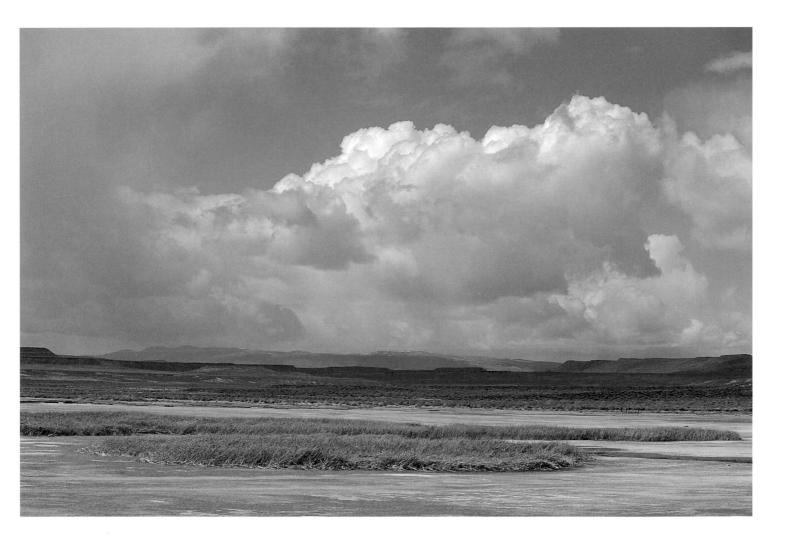

(facing page, above) *Jackson Mountain Cave;* (facing page, below) *Granite Mountain Lady;* (above) *Clouds,* Bog Hot Ranch

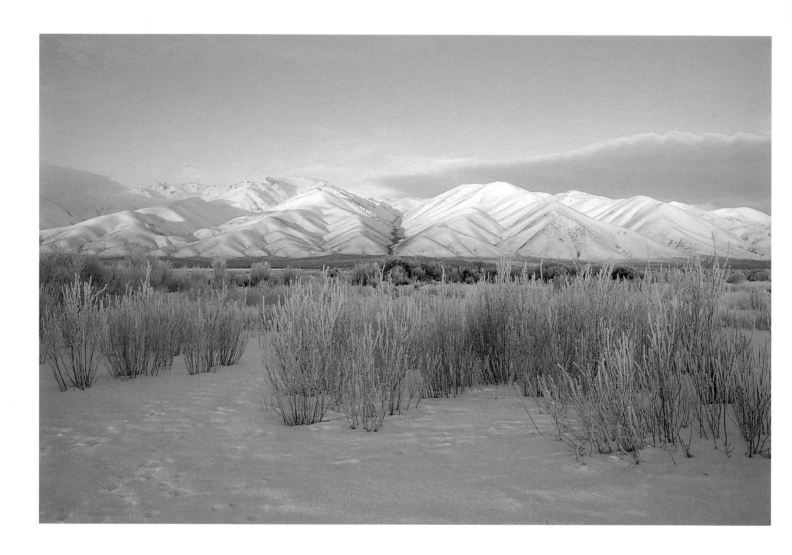

Icy Winter

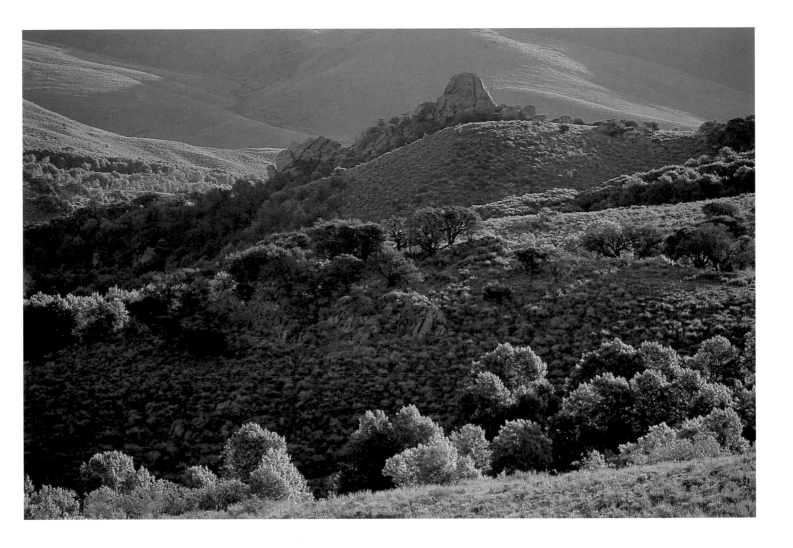

Summer, Lovely Valley

Southward

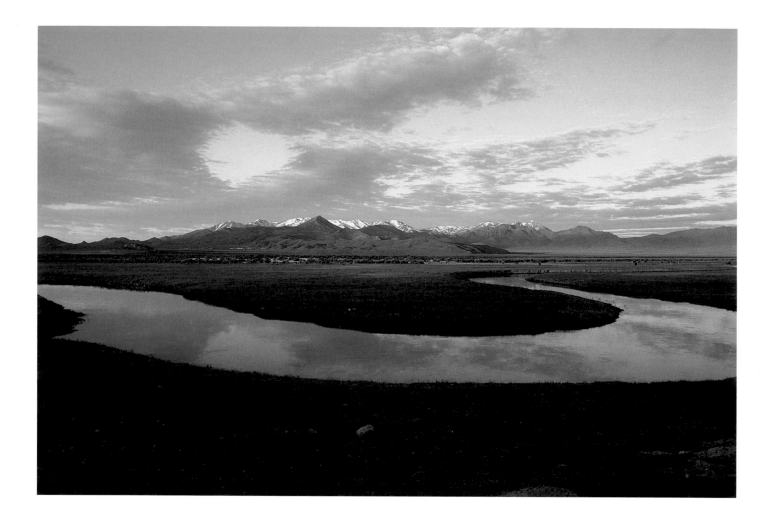

Bend of the River, North Jackson Mountains

The Quinn River heads in beaver streams on the border between Nevada and Oregon. Like most desert streams, it wanders reluctantly most of the year across the valleys. It skirts the ends of three mountain ranges in an oddly angular westward progress, following the lines of fault blocks hidden thousands of feet under valley sands. It creeps finally around the end of the Jackson Mountains, where the currents of Pleistocene Lake Lahontan sifted and rolled volcanic pebbles into a long gravel bar. The bar points north, a gnarled finger, into the ancient lakebed. The river slices through it at the first knuckle, then meanders slowly south to die in the alkali of the Black Rock Desert.

In the first knuckle of the finger lies the headquarters of Quinn River Crossing Ranch. The river has cut the swath, and there is cover here for men and animals; shelter from the Black Rock windstorms, good feed, and water. A hundred-odd years ago, someone recognized this place and built a homestead in the wide cut in the gravel bar. Now the river flows through fenced pastures, down the meadow's west side, separating miles of wild hay from greasewood flat. Bluejoint grows nearly head-high over a mat of clover in the lower meadows, where the river spreads out half a mile into shallow sloughs full of rushes that we call tules (too-lees).

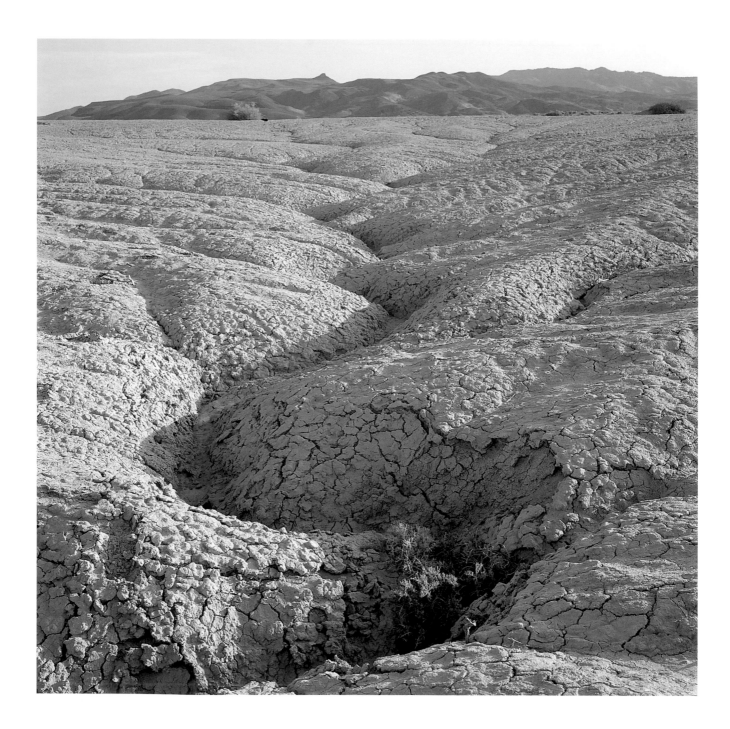

Black Rock Desert, Sentinel Peak

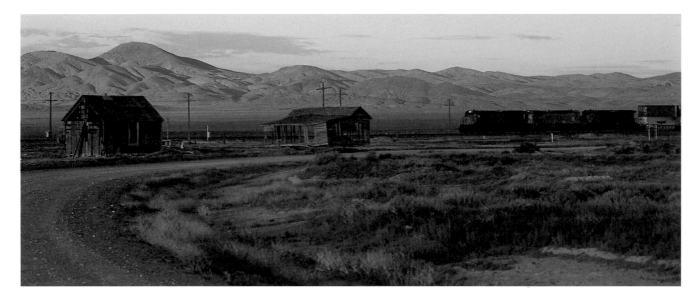

Western Pacific Train at Site of Sulphur

When snow is on the winter desert, if you look south the way the river runs, your eyes stretch to meet a wavering horizon. It is like looking across the ocean, across time. Cold-air inversions play tricks of eye and ear usually associated with summer heat: on a cracking cold morning in January, the wail of the Western Pacific freight train comes clearly across forty miles of silence, arcing up into layers of warmer air above the valley floor and back to earth, as though the freight pounded past the ranch just outside the pasture gate. Shimmering waves of cold, not heat, make mirages of faraway mountains; peaks below the horizon quiver in an unfamiliar, floating skyline that disappears altogether with a slight change in altitude. It can't be called a heat wave, the difference between fifteen degrees and five below zero, but the shimmer and the false horizon are the same.

Along the sand dunes, hidden in the alkali, is evidence of peoples who lived here before us, hunted the foothills and the

dunes. Obsidian shards, edges worked, glint in the cold sunlight.
I squint across the frozen desert and imagine that I see the fleeing
band of renegades as their pursuers saw them on that January day
in 1865.

Eighty men, mounted cavalry, crossed this frozen gravel bar,
just there, below where the ranch is now. They pursued their prey
through the winter darkness. The soldiers lit no fires. They ran
in circles in their darkened camp to keep from freezing.

The newspaper had reported a renegade band on the run.
Settlers were nervous. The War Between the States was nearly
over, and soldiers moved west into new postings, soldiers sea-
soned from, numbed by, years of war. The *Humboldt Register* of
January 20 reported: "The Indians had the advantage of the
ground . . . two miles square, covered with tules, tall rye grass,
and very much cut with gullies and ravines. The Indians discov-
ered three columns coming about a mile distant. They could be
distinctly seen preparing for battle: dividing off into squads of
from four to six, selecting their places of combat where it would
be most difficult to maneuver cavalry. Each warrior had from
fifty to seventy-five poisoned arrows, giving each squad two hun-
dred and fifty to three hundred shots. The moment before the
battle commenced, owing to the extreme cold, a dense cloud of
frost commenced flying, so thick that a horseman could not be
distinctly seen over a hundred yards. This gave the Indians a great
advantage, as it compelled the soldiers to fight at short range, so
that bow and arrow could be used; and it also increased the
chance of escape for the Indians. The plan of battle was such that
the right and left columns flanked the Indians, and soon sur-
rounded them. They arranged their arrows in such a manner that

they could shoot very rapidly, and charged with as much bravery as any soldiers in the world.

"The battle continued in full force for two and a half hours, when the conflict was reduced to two points, at which several warriors had selected deep short gullies, and were making what they knew to be their last fight. . . . The leader of the band, Captain John, having one man with him, was defending himself with skill [with a] bow and quiver, and . . . the identical rifle with which he had killed Colonel McDermitt, and a soldier named Rafferty last year. . . . Knowing he must die, he determined to sell himself dearly. After a great deal of sharp shooting, Corporal Rapley succeeded in shooting him through the head, and Captain John was dead.

"The battle, with the exception of a few straggling shots, was over. The Indians had fought with a heroism that astonished everyone who witnessed it. They made no offer to surrender, and continued to fire their poisoned arrows until they were so weak that they could throw them but a few feet; some, when dying would shoot an arrow straight up into the air, in hope that the deadly missile would fall on the hated and victorious foe. At the close of battle thirty-five Indians lay dead on the field with their bows and quivers still clutched in their hands. All were large powerful men—a picked company of braves, prepared for battle. But five squaws were in the band, and they were acting in the capacity of a pack train. Two of these were killed in the battle by mistake; the other three were furnished with some provisions and left unmolested."

The frozen horizon of Pinto Mountain shimmers and shifts as the sun warms the air above the valley floor. I imagine what those

women saw, coming at them across the valley on that other January morning.

We see them coming through the cold winter dawn. We have known they were following, and our chief has brought us to this place to wait. The hot water bubbles in rivers beneath the earth; clouds of steam hide us from our enemy. They will meet us on our terms.

We are the best of our band, and several other bands. They are the best hunters, the most courageous warriors. And four women, besides me, to cook and carry and mix the poison to tip the arrows of our men.

The ground is broken here. A horse can break the crust of earth and step into the hot water, or break a leg. They have a lot of horses.

It has been very cold all night, and we have sung and prayed and fasted to be ready for this day. They come fast now across the valley in three lines. The cold air makes their shapes waver like the heat of summer, with the sun warming the earth now in the rising light. We are in seven groups of five, waiting in the places that will be the hardest to see.

We are silent for a long time watching them come. Clouds of steam and ground fog hide us from them until they are very close. Then someone shoots an arrow, and they know we have the poison. They have a doctor, and he gives the men a medicine to counteract the arrow's gift of death. Twelve Paiute scouts ride with them. Perhaps the scouts have told the soldier doctor the secret of our arrows. We can only wound them.

Our men lace the arrows between their fingers, so they can fire rapidly, but we have only one rifle. They are eighty mounted horsemen, and they all have rifles.

We kill seven of their horses, and wound nine of them. Our warriors sell their lives dearly; take six rifle bullets before they fall. But in the end they fall.

Now we are three women; the winter silence and the steam from the hot water surround us. The soldiers leave us here, with our dead husbands and our brothers.

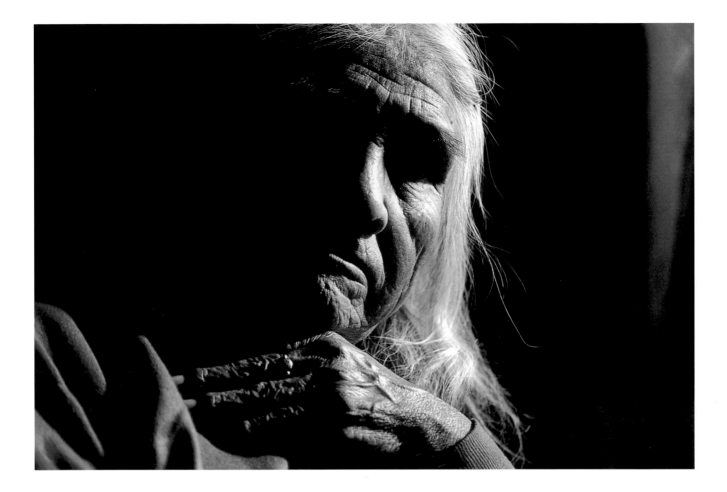

29 *Hazel Crutcher*

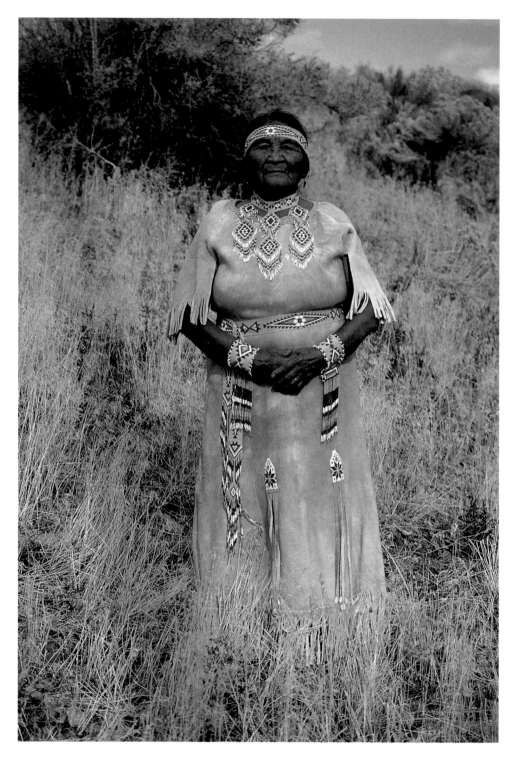

30 *Eileen Smart*

They do not see the children, hidden in the canyon under woven rabbit blankets, who will starve slowly now.

Their bodies, the bodies of our men, are too heavy to move alone, so we work together before they freeze solid in the freezing air. They have killed us all, and for a long time we can see them walking away from us, surrounded by their victory.

From the *Humboldt Register,* January 27, 1865: "Some may be surprised, reading the account that we published last week, that anything of a desperate character should be ascribed to a fight between eighty men with Maynard rifles against thirty-five Indians with bows and arrows. The clouds of flying frost obliged the riflemen to come to close range, in order to shoot their enemy. This was in favor of the bowshots. The arrows were known, after the first one had been shot, to be poison. This was chilling information. Then, these wild Indians would stand up and deliberately fire their deadly missiles after receiving in their bodies as many as six of those heavy conical shots which the Maynard carries; and would let fly their arrows with their last breath; whereas one of the leaden shots so carried by them would have knocked any white man out of time."

No one knows exactly where the "battle" of Fish Creek Valley took place. Local historians place it somewhere below the Pine Forest Range. Descriptions of the landscape suggest this part of the Black Rock Desert. But in a country of winter mirage, who can say?

GORILLA FIELDS

In latest winter, a thin sheet of ice covers the slough. The river spreads out beneath it across the meadow, flowing south toward

the desert. In places the water can be seen pulsing under the ice, half a mile wide, three inches deep: a wide blue heartbeat beneath winter's armor.

These are the farthest meadows, seven miles below the main ranch house. There are three Gorilla Fields, wild meadows following the river's course. Billy Scossa was the hired man, mechanic, keeper of all stories, mentor in many things to the small pack of boys who lived there then. He explained the origin of the name. Of course, the stories were told after dinner, in the bunkhouse, without benefit of parental interference.

"There are ferocious creatures, you know, who live in the tallest ryegrass," he explained to the young boys who would learn to help with haying in the morning. "Gorillas. That's why the grasses move like that in the breeze, you know." Small boys ran yelling off to bed, only partly believing.

Yet the next day, when the breeze rippled through the meadows exactly as though an unseen creature passed within, the reaction was all Billy could have hoped for.

The real name for the meadows came from Spain: *grulla,* the color of the mythic Spanish mustang. It is not gray, nor brown, but a soft buckskin. It is the color of this meadow in autumn.

One year in October, thirty haying seasons later, Grandpa takes another small boy, Sam, with him to the Gorilla Fields. They have only a box of matches with them. Grandpa needs to burn the acres of tall whitetop that have crept up the river from somewhere, invading the lower end of the Gorilla Fields from the county road that crosses below them. They drive clear down to the lower fence, bump-bumping slowly over the miles of dry

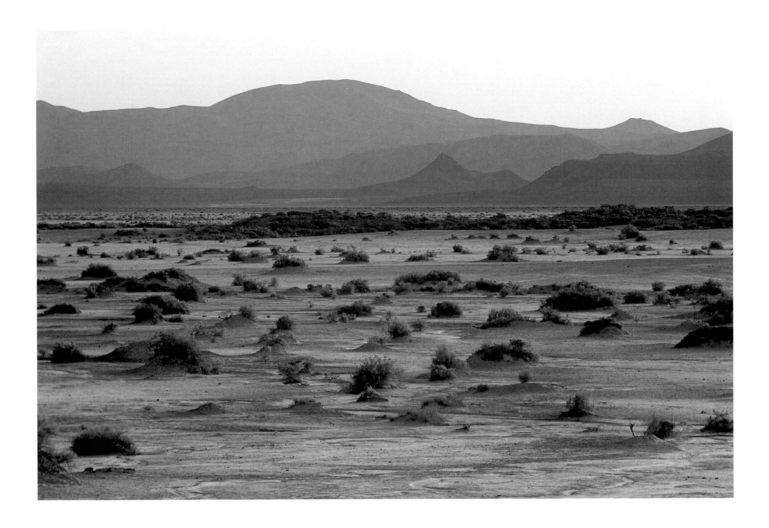

33 *Black Rock Blues*

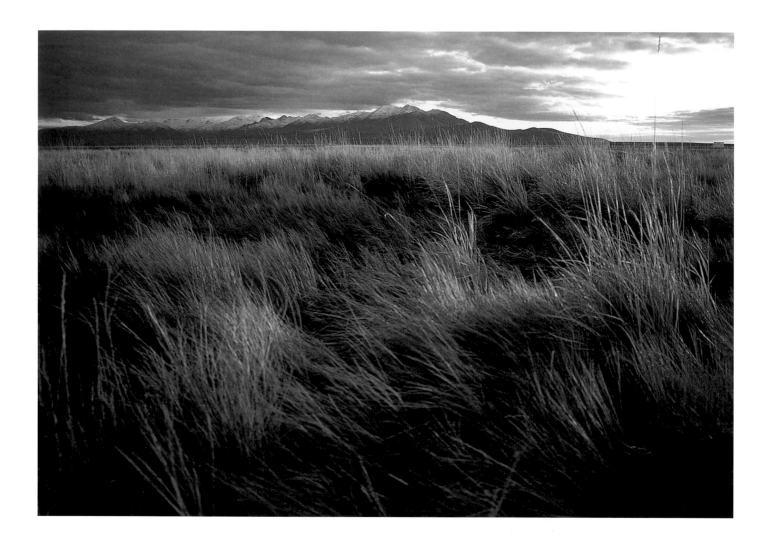

34 *Fall Grasses*

sloughs. They start a little string of fires across the meadow that the breeze soon makes into big fires.

Grandpa doesn't get excited. He drives along ahead of them, lighting the dead tules that are choking the ditches. Burning the vegetation off will ease the flow of next spring's runoff down the channels. It's part of the fall and winter cleanup, something people used to do every year at the end of the growing season, at the end of the grazing season. Men say the local tribes would burn the canyons in the fall, to clear out the dead grass and brush, make way for the next year's growth, keep from building the fuels that would make a summer lightning storm a disaster.

Still, Grandpa keeps a close eye on the fire. He watches with Sam from the top of the gravel bar, where you can see all the way down the fields, until it is time for Sam's supper. He drops the boy off. Then he comes back, and drives the edge of the meadows in the dark. He watches the line of flickering red flame move slowly against the blackness of the desert night. The fire will keep burning in the cool night, but by morning it will be dead. He remembers another fire, one that did not behave so well, that did not die out by morning.

Jesus did not come in to lunch that day in early March. The cook's bell rang at six, twelve, and six, and the twenty field laborers and cowboys and whoever happened to be driving by the ranch would come in to eat at the long yellow table in the cookhouse. He had been over in the horse pasture, burning stubble, someone said, getting ready for the water that would irrigate these meadows soon.

It had been a quiet morning, but on the Black Rock, the wind can come up fast and fierce. It was blowing hard now, nearly sev-

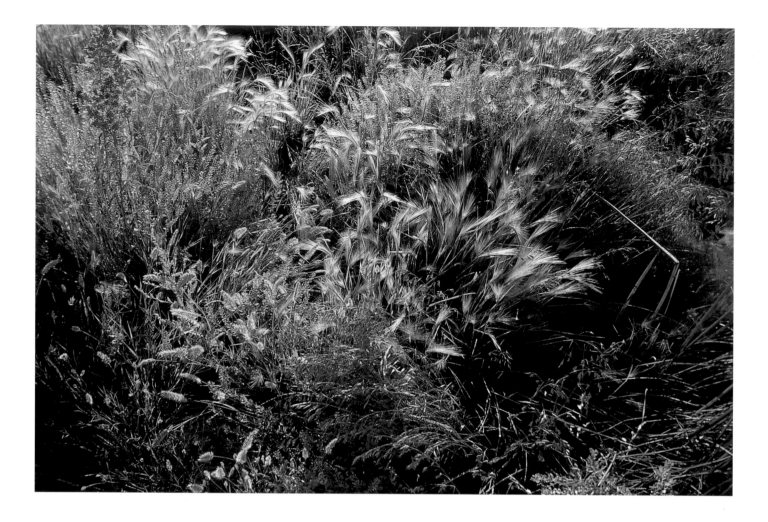

Medley of Fall Weeds

enty miles an hour by the time Buster drove from the cookhouse down to the pasture, about fifteen after the hour, to see what had happened to Jesus. He was shoveling and shoveling, frantically trying to trap the little clumps of dry manure that were burning.

"The wind just kept bringing it, rolling those clumps of dry manure, and every time, another clump would light on fire, and then they would both come." By the time Grandpa could race back to the ranch to warn the others, the wind had brought the fire nearly there. It had crossed the mile of meadow in fifteen minutes.

The telephone operator, for there were still telephone operators then, called the neighbors, a lot of neighbors, to tell them. It was much too far from town for fire trucks to come. The only possibility was to fight this fire by hand, to try to save the buildings and the corrals.

The fire roared straight into the houses and the barns. It was nearly shipping time, and all the corrals were full, three thousand head of cows and calves, horses, pigs, everything, trapped behind the barn in a network of gates and alleys. Choking smoke engulfed the buildings. Neighbors kept arriving, some from as far away as McDermitt, seventy miles distant. Men and vehicles appeared and disappeared like ghosts in the haze.

The family went first to the corrals. There would be no time to herd the animals out. They could only run down the alleys, throw the gates open, hope the animals could find their way out, that they would not be trapped. Tim and Ron, teenage cowboys, ran through the barn, trying to save the saddles and the bridles that would help them gather whatever animals escaped the flames.

The roof was burning above the boys as they ran down the

rows of tack, hauling armloads of snaffle bits and bridles. The fire sucked the oxygen out of the barn, and there was no air inside to breathe. Tim fell, choking, to his knees. Arms full, he gulped the smoky air at the barn door. The roof caved in behind him.

The cook fed anyone who came in needing food, all day and into the long night, after the fire had burned through the yard, burned the sheds, the barn, but left the main house and the cook's place intact. The boys fell into their beds at two o'clock, eyes streaming with smoke, nostrils clogged with soot.

At dawn, they woke to find rows of pickups parked in front of the main house. People had stayed, or come sometime during the night, with horses and saddles, to help them gather the stock they'd freed the day before. And they were all out there, all the cattle and horses and pigs and dogs. Not one animal had been lost.

The worst of it was that, all summer, since the corrals and the barn had been burnt, the hogs had the run of the ranch. There were other priorities before rebuilding the hog pen, and those hogs chose to bed down under Tim's window and scratch against the wall all night, all through the summer, scratch and grunt, while the cowboy in the next bed snored.

BLIZZARD

Once the sheep leave for the winter country, they are gone. Each day the trail takes them further south, one, two, three long valleys away, down gravel, and then not even gravel, roads. Someone drives down every few days to move the herder's camp, in winter a little white metal house on wheels; take him a pair of boots, some

oil, and more batteries. It is vast empty country, even by our standards, those valleys that fringe the Black Rock playa.

"Oh, not until March," the man who sold them the new sheep had assured them. "They won't lamb till March, maybe early April." It should have been a good deal, those older ewes. Buster and Hank had agreed, and now the sheep are well on their way to the winter country. The truck rumbles south, heater roaring, trying to keep up with the wind. It's an arctic wind, stronger by the hour, blowing in the seams and cracks, chilling the windows.

The ruts are frozen today, so the trip is rough, but Hank won't get stuck. The horse trailer creaks along behind. We passed the last of the widely scattered ranches the better part of an hour ago. The road snakes through low gray hills, an interference of little waves between mountain ranges. As the snow starts to spit, we come upon a small enclosure, steel posts and wooden pallets, in the middle of this empty place. In it are perhaps ten ewes, heavy with winter wool—and lambs.

A sheep does not show the closeness to her lambing in the same way as other animals. She will carry lambs five months, but a month from parturition looks like three, and although these sheep should not be close to lambing, some have already given birth, and the rest of them could start at any time.

Hank stands in the icy wind, untying the makeshift gate with freezing fingers. He wades into the bunch, lifting the old ewes into the trailer. They are stubborn, resentful. They just want to find a bush to tuck their lambs under, but there is no cover here. It's not lambing country. The lambing grounds are two months and seventy miles' slow grazing up the trail to the north. No one would choose this, but this is where they have found themselves,

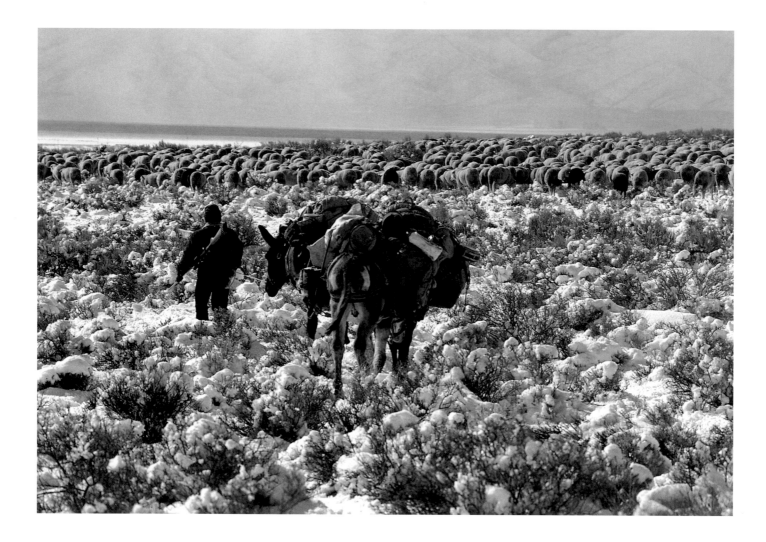

Winter Herding

the sheep and the men who care for them, and there is nothing for it but to get through it. The last old ewe lay stubbornly, huge, a gray lump on frozen earth. "Come on, get in the trailer. Stand up." My brother-in-law's hands were red, cracked. The wind flung pellets of snow sideways. Soon the storm would be on us.

The ewe groaned. In two hours he could have her home in the comparative warmth of the barn, straw on the floor, a pallet pen, a heat lamp, companions chewing hay next door. The first lamb slid halfway out in one push. "Oh, hell," said Hank, more a prayer than a curse. He shut the door of the horse trailer. I walked to the cab to see if there was something to use for a towel. I came back shaking the dust out of an old gray sweatshirt crammed down behind the seat. The first lamb was out, sopping, quivering in the thickening storm. I remembered the frozen corrals at home, a tiny white lamb frozen solid to the ground before he could stand up. The men stood in a knot around the ewe, waiting. It didn't take long. In a few minutes the second lamb slipped out. The ewe lay still, staring at something in the distance.

"They can't live, can they?" I asked, looking at the frozen earth that had received the early babies. He sighed. "They can take a lot." One massive hand clanged open the trailer door. The lambs' heads wobbled. Incredibly, they woozily clambered to their feet as Hank sunk his other hand into the deep wool of the ewe's shoulder, one knee under her. He levered her hundred and eighty pounds into the trailer. The two lambs stood, feet apart, shaking their heads, tasting the dry, cruel desert snowstorm. The wind blew harder. We lifted the babies in next to their ancient mother, shut the door on them, and turned for home.

And so the ewes kept lambing, in the winter desert, life coming against all odds, against all common sense. Hank or his father, or both of them, made the drive, once, sometimes twice or three times a day. Sometimes it seemed as though there had never been any other existence than lifting the ewes in the freezing cold, into the horse trailer, into the back of the pickup. Hank tied a string around the leg of the ewe, and around the corresponding leg of the lambs, to identify the pairs. They seemed to forget each other in the first day of their common life: a string around this front leg of this pair, around the neck of that one with twins. Load up, bump off up the road, hours to the ranch, unload, come back, move the panels and the steel posts from their frozen place between low hills to another frozen place between other low hills.

The band moves like a slow cloud across the desert landscape, southward before the winter wind. Ewes that lamb cannot be left behind to rest, as a lambing ewe should be allowed to do. The lambs cannot travel for a day or two, but in this country they will not survive a day or two in isolation. Coyotes, bobcats, cougars are all hungry in winter.

So Hank spent that winter ferrying the old ewes home, through wet snow, flat tires, failing fuel pump. Once home, lifting them out of the truck, into the barn, building the honeycomb of wooden pens that will shelter them—and separate just the one ewe, and her lambs from the others—until they learn each other's warmth and smell. Fresh hay, another pan for water, another stretching extension cord, and another heat lamp wired to the beam or to the nail in the wall. Build the pen, unload the sheep, feed and water, gas up the truck, and go again. January, February, March.

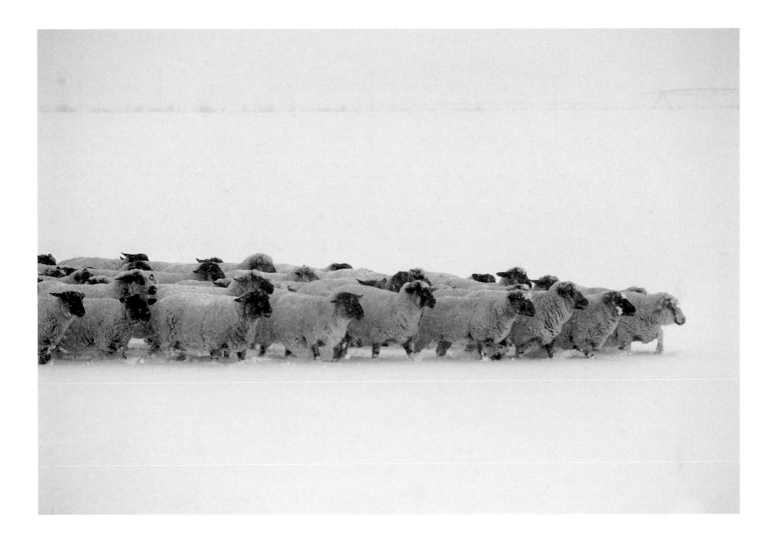

43 *Ewes in Snow*

This day was only one day in a long string of days, the product of all the days that had come before, a foreshadowing of days that were to come. But the sun still made its progress through the sky, and each day it warmed the earth a little more. The sheep turned around at last, and made their long, slow way back north, to the home ranch, to the lambing grounds, to the relative kindness of the spring.

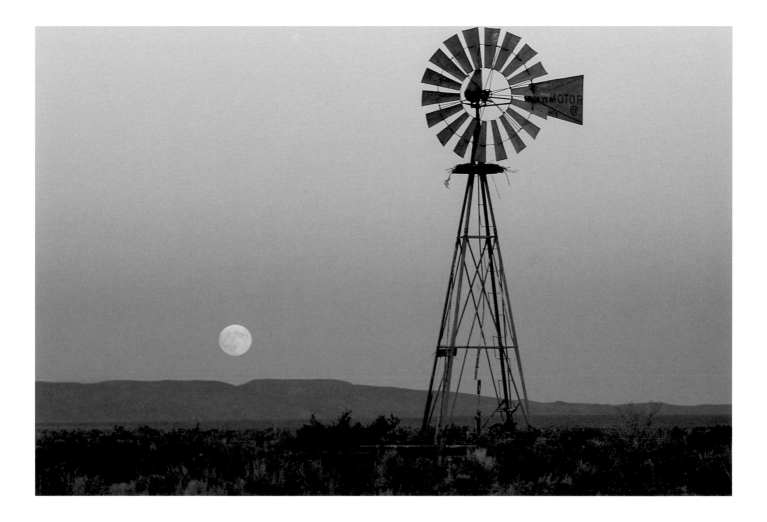

Moonrise Windmill

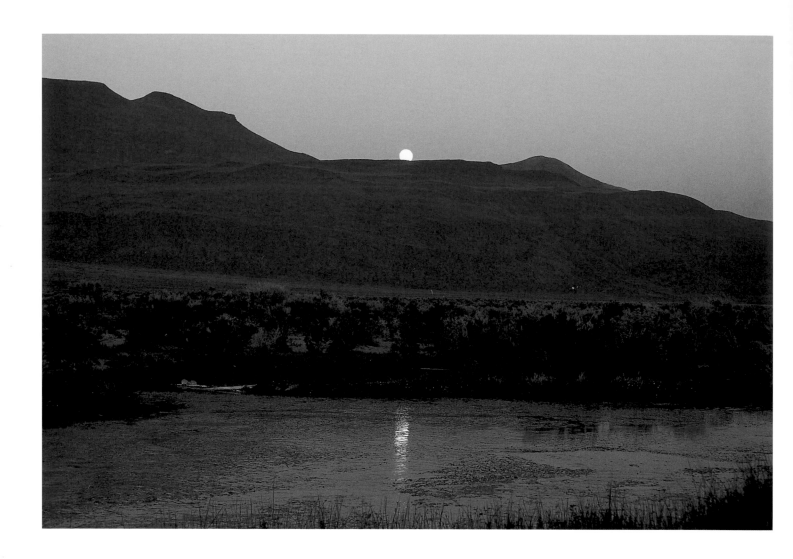

Moonrise over Hot Springs

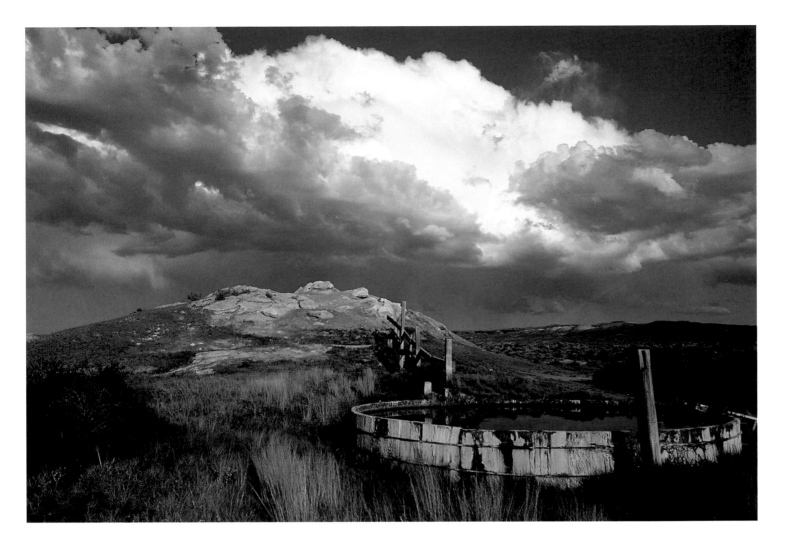

DeLong Hot Springs

(above) *Low Tide on the Desert*; (facing page, above) *Popcorn Weeds*; (facing page, below) *Desert Peach*

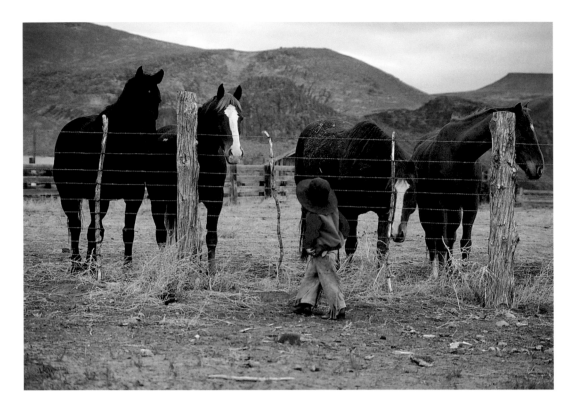

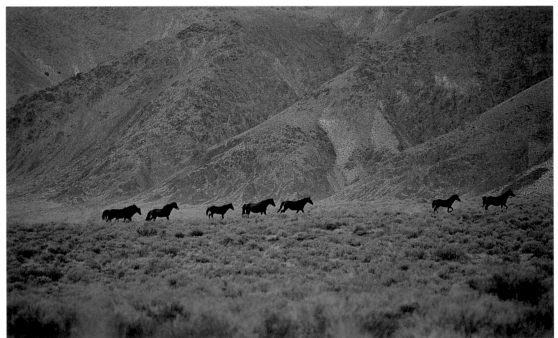

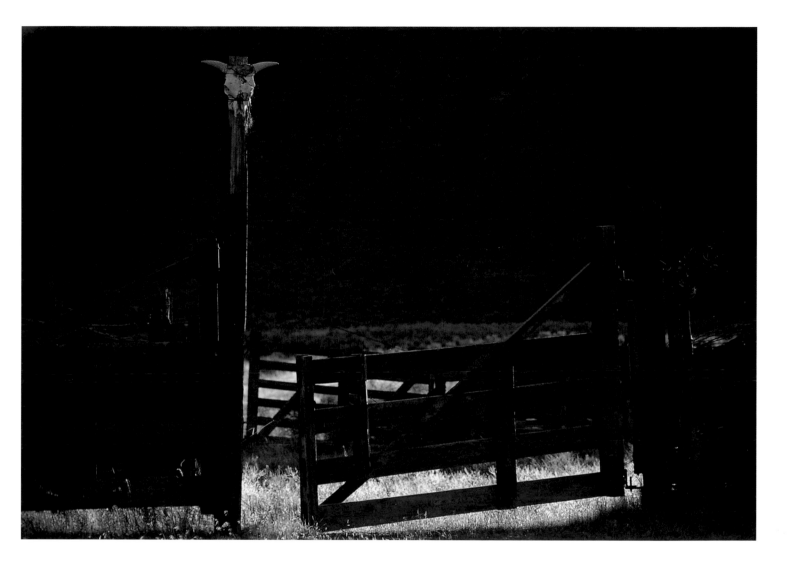

(facing page, above) *Oh, No, Here He Comes Again!*; (facing page, below) *Jackson Mountain Mustangs*; (above) *Ghost Gate*

Eastward

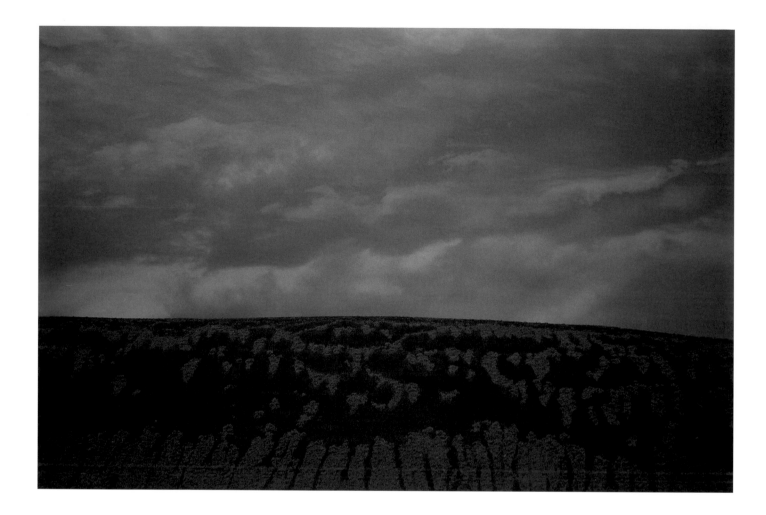

54 *Untitled*, Red Lava Flow

The mountain to the east of us is layered with red volcanic flows that slid out over the land fifteen million years ago. They cooled, and sat, life going on above them, for ten million years before the tearing and the tilting that shaped the Great Basin built them into mountains. The flows form sinuous red- and cream-colored stripes along the backs of long north-trending ridges, faulted down into steep, brush-choked canyons and back up, the same rock appearing and disappearing, repeating itself across miles of country. The red rock breaks into wide slabs, whose cool under-side in summer can always shelter a rattlesnake, sleeping in the heat of the day. These are the lambing grounds, the spring country of the sheep.

SAVING BADGER

It is pouring rain. The mud-spattered yellow pickup rattles to the front door, and Hank climbs out, water sheeting off his yellow slicker. He opens the passenger side door and leans into a pile of soggy gray lambs, just hours old. Their skin is wrinkled, the wool short and nubby; they are all legs. Some are twins or triplets of ewes who will be unable to raise more than one lamb; some have been left motherless by coyotes or bobcats. One, inexplicably, has no wool, no skin, on his back legs.

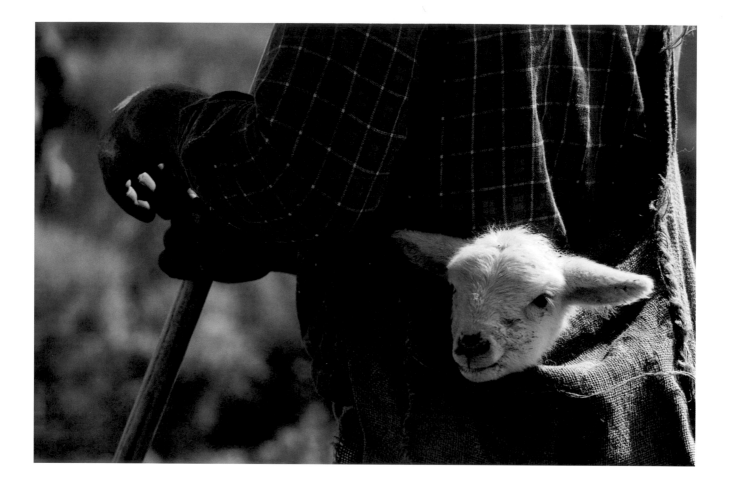

The Orphan

Somehow, he has taken his first steps, or perhaps was even born into, a deep badger hole. Badger holes are big, big enough to conceal a whole lamb, gangling legs and wobbly head. This big-boned baby must have struggled in the hole for hours, cried till the herder saw the ewe out there in the brush, standing alone, he thought. As he came closer, he heard the lamb crying—somewhere. Finally he reached down, arm's length, brought the lamb into the open air. The orphan's name, of course, will be Badger.

Hank's wife names all the orphans, some for friends or visitors, some for the circumstances that bring them to her kitchen. They don't look much like they'll live when they come off the floor of the yellow pickup. Still, she tries to get some warm milk into them, and plunks them into the cardboard boxes near the kitchen stove, under the heat lamps, out of the cold. Soon there is a great rattling of newspaper and thumping from the kitchen. Muttering, and then a bleat or two, and the lamb will be standing in its cardboard playpen, shaking its head, hungry.

Linda and Ginny, and Ginny's two daughters, feed the orphan lambs, called leppies, as many as four times a day when they first arrive. The bigger lambs seem more awkward. They have a tougher time than the small ones, longer, ganglier legs to get control of. Badger slept on a heating pad in the kitchen for several days, his long, raw legs draped in a towel, until he gathered his strength.

When they're strong enough, they move to the lamb shed, a long wooden shelter on skids made of telephone poles, just across the drive. The shed is divided into pens of six, eight, ten, twelve orphans each, each pen with a sliding door cut in the wall of the shed to divide in from out, outdoor playroom from inside

warmth. There have been years with a hundred lambs to feed three times a day, a hundred babies to bring in at night, put out in the afternoon to the warmth of the sun.

Leppies learn fast. Soon they are nuzzling up, seven at a time, to a sixteen-ounce Coke bottle with a rubber nipple, long tails wagging like puppies. Three times a day for four or five weeks, learning to nibble hay and alfalfa pellets after two or three weeks.

It's not always so sweet an ending. Ginny's daughter Magen writes this elegy for her eighth-grade English class: "It was a cold morning and it had been a cold night. The lamb weighed less than five pounds. He was a triplet. He was very cold and almost motionless. I fixed him a bottle of warm goat's milk and tried to get him to drink, but he would not. After we did all we could, we went to the barn to feed the other lambs. When I returned to the house I saw the lamb's stiff lifeless body, laying by the fire where we had left him."

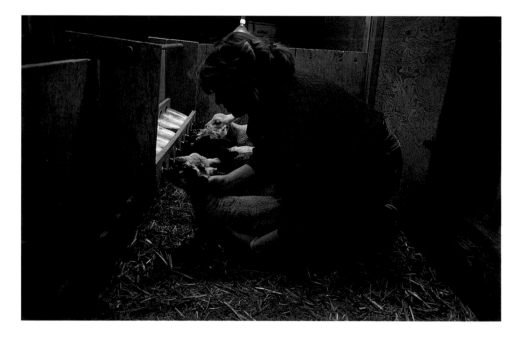

Ginny Feeding Leppie Lambs

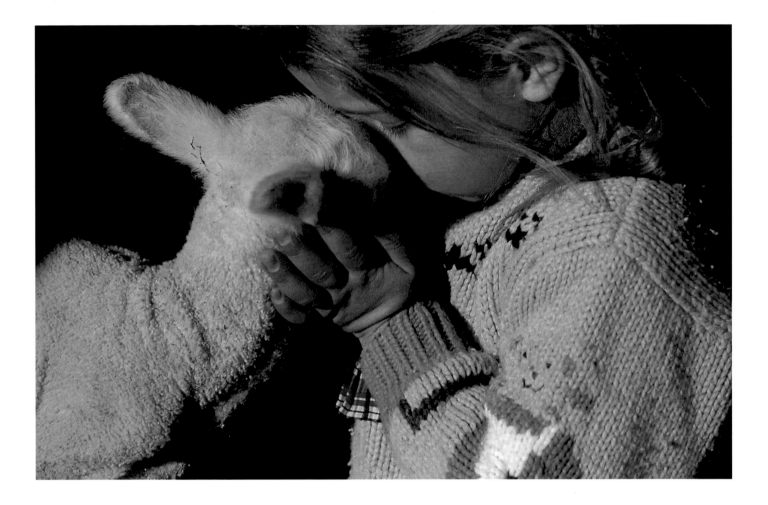

Lamb Love

Little Softie

In a couple of months, Badger and his compadres are turned out in the pasture across the drive. As spring warms into summer, Badger grows stronger. Cinnamon wool covers his long legs and his triangular face. He's not the most beautiful lamb, but he is a survivor. He has survived the first day of his life, coyotes, mountain lions, enterotoxemia, and the sore mouth that strikes the leppies in the barn, making them unable to eat. He's spent his summer nibbling the orchard grass, lounging in the shade of big willows by the trough, and as with all his mates in the pasture, someone remembers his name.

MARKING TIME

It is the time for marking lambs, late enough in the spring for there to be snakes. On the road through the red canyon, someone has hung a huge dead rattler head-high in the sagebrush beside the road. His tail drags the earth, a warning to travelers—and perhaps a herder's victory statement.

The ring of sagebrush where we will mark the lambs is perhaps four feet tall, its walls as thick as they are wide. Living sagebrush grows in the walls, the manmade fence and the living desert woven together almost seamlessly. It is an oval ring high on a sloping ridge, built tilted into the rising sun, sheltering the animals inside it from the wind, warming them with the dawn. No one knows who built it, or how long ago. We use it once or twice a year. The rest of the time it is an artifact, a structure so subtle you might not even notice it when you drive by, in a place you would never drive by. It is the last of its kind, although there were once many like it in this country.

We sleep in cots, up off the ground, but not in tents this year.

Canvas and heavy denim quilts cover our blankets and bedrolls to keep off frost. It is very early in the morning. Black silhouettes of family and friends who have come to help are backed with a few late stars against the clear purple of the coming morning. We dress quickly inside our bedrolls, stick our feet into frozen boots. There is no fire yet. We will eat after.

We spread out silently around the little cup-shaped basin, tilted to accept the sun's liquid warmth. The sagebrush oval is on the hill above us. We take positions in the tall, sharp-smelling brush, listening for the sheep. It is important to stay quiet, not to startle them as we turn them into the corral. We wait, and finally they come. The herder brings them slowly, just before the sun creeps down the red rock ridge. Dusky white shapes mutter to each other; brass bells sound in sagebrush. They move slowly, easing away from the human shapes standing silently, guiding them toward the corral. The sun pours light through the dust as they funnel through the gate, mill around softly, calling their lambs.

Our children comb the hillside, looking for dead branches to make the fire. It will keep the red branding paint liquid in the cold morning and warm their cold fingers and toes. They pile brush into a heap taller than they are, feed the little fire until it is roaring.

Below the corral is a series of small paneled enclosures, into which are funneled bunches of thirty or so sheep and lambs from the big pen for marking. This big bunch stays quieter this way, as the dogs and herders and kids don't go into the big pen as often through the morning. The young boys leap over the fences into the marking pen, wade thigh-deep through lambs, looking for

the ones they can hold. The old Bascos stand outside the pen, their musical blend of English and Basque, Spanish and French a beautiful low murmur of language on the steam of their breath in the early sun. "A little frosty this morning," Frank always says, *r*'s rolling. And it always is. This is the day the sheepman learns how his year will go. How many ewes have twinned, how many lambs the coyotes and cougars have taken. Anticipation floats in the frosty puffs of breath above our heads. "Good-looking lambs," the Bascos say. "Big, stout lambs."

We line up outside the pen, behind the men who do the docking and castrating. They wrap adhesive tape around their thumbs, and face the holders, lined up inside the pens in a sea of white wool. They are the only ones whose legs are warm. We give shots, stamp a red circle brand with paint between the lambs' shoulder blades. It goes on and on, trying to be quick, and still gentle with them. The holders' hands grow stiff and sore from holding thousands of squirming legs. We begin at dawn, finish when the sun is high. There are no breaks.

After the pen is empty of lambs, the ewes are counted out, to run anxiously for their children in the brush and grass nearby. The little cup-shaped basin echoes with the sound, mothers calling children, children answering.

Knives are folded, adhesive tape stripped from thumbs. The children bury empty vaccine bottles deep in abandoned badger holes. A second fire is kindled, near the paint fire. Loaves of French bread appear, home-cured ham sliced thin and wrapped in aluminum foil, chorizo, blood sausage from the front seats of pickups. There are hard cheeses, red wine. We slice onions into the huge two-handled sauté pan, cook potatoes, eggs. We stir the

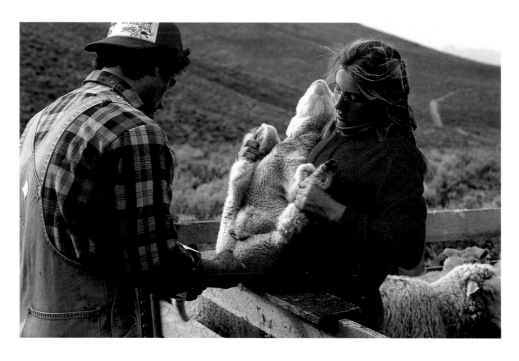

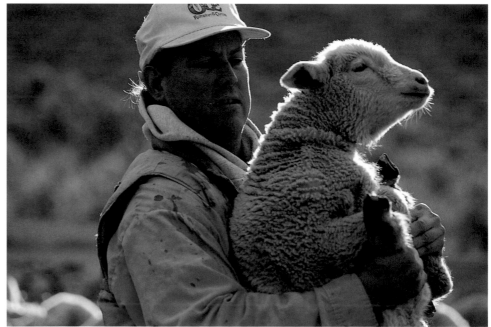

64 (above) *Docking Lambs;* (below) *Jackson Cayot Holding Lamb*

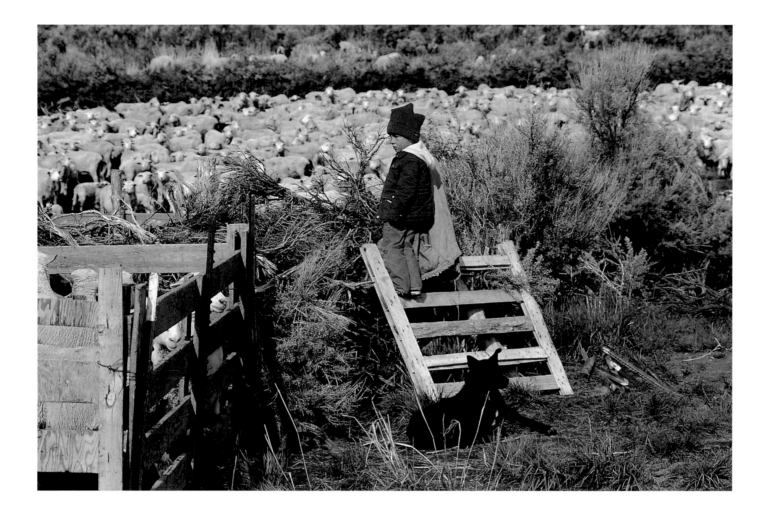

Watching the Docking

pan with long-handled spoons, turning our faces away from the heat of the fire. Voices rise and fall in Basque, French, Spanish. The docked tails are counted and checked and figured against the lines of numbers on a piece of cardboard box lid, representing the ewes counted out. Pete shows me how he learned to divide the numbers as a boy in the French Pyrenees. It is a mysterious, tidy algorithm, long division arranged around the quadrants of a central cross. We get the same answer, 125 percent.

Soon it will be clear how the rest of the year will go, whether there will be worry-creased foreheads or quiet celebration. One year it snowed at marking. One year the lambs were raked by a lion that came through the band the night before the marking, batting and playing until in the morning fifty of them lay dead. One year the front of the pickup was full of wobbly-necked babies gathered from the bed ground, their necks and heads oozing blood from the puncture wounds of bobcats. We took them to the ranch, to be bottle-fed and cleaned up, nurtured. Most of them died.

Marking time is a turning point. The lambs that come in to marking have made it through the first six weeks of life. They have survived the transition from April to May, from winter to spring, and have survived the desert, which will become their home. These are the lambs we count; we see roughly those ewe lambs that will be taken into the band, the wethers that will be fed this fall and sent to market. Marking is a look forward, and a look back. Each year we repeat our tasks, sometimes in another place, on a different day, variations on a timeless theme. Each year our children grow taller, our friends a bit frostier around the temples. The brush corral is mended and left till next year, the territory of

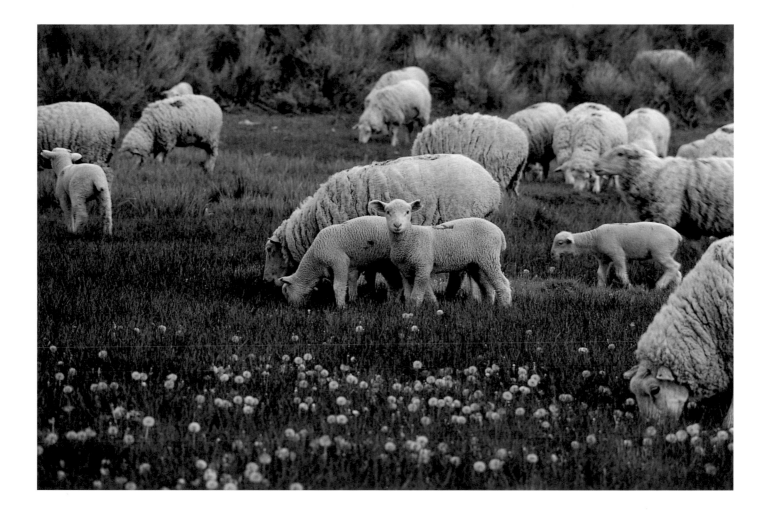

Sheep in the Meadow

ground squirrels and badgers, snakes and hawks. It will be there, the oval on the red rock hillside, changeless as the mountain.

THE RESERVOIR

Colorless earth bakes in July heat. Naked outcrop surrounded by bleached grass hides moisture from the punishing sun. Clouds of alkali powder follow my truck into the canyon at the south end of the range. The earth has split the mountain along its spine. A creek funnels down its cleaved center, earth and rubble dam blocks its small progress, spilling into a triangular basin of perhaps twenty acres. Scrub willow thickly fringes the margins, softening the basin's treeless contours. It doesn't look like much of a reservoir. Still, it waters our alfalfa fields and ryegrass through the summer.

Ten years ago, a flood washed out the spillway of the little reservoir. A decade's erosion carved meandering channels into the silt and gravel of the catchment. Sagebrush and scrub willow encroached across the bottom until only a fetid brown puddle remained behind the dam. Ancient rusted gears poked out of concrete, clues to the pipe buried beneath tons of mud. A dead thing. A decade of drought after a flood year is as devastating as any natural catastrophe.

The new owner was only through here for a day, but he looked at the reservoir. Then an engineer showed up, and some men in trucks from California drove the canyon. Rock was hauled, the scar chocked and healed with tons of earth, sealed by a winter's thick snow. The next snowmelt brought too much water; the excess pouring through culverts partly crushed and clogged with God knows what from years of neglect. The water level in the res-

ervoir rose, even with the valves open all the way. There was too much debris in the pipes.

Wavelets lapped the top of the spillway. The cowboy worked in his waders, crawling into the dark, half-crushed pipe at the bottom end of the dam, pulling out sticks, nests of half-rotted leaves, Budweiser cans, shovels of silt. The blockage had to be cleared before the level reached the top, spilled over the new rock-and-earth patch of the east end, and washed out all the new work of repairing the dam.

There are so many jobs in this way of life that are dangerous, but are things that have to be done nevertheless, often alone. The cowboy clears the half-crushed culverts without drowning. The valves open, the water pours through. Water pours through, all during the spring and into a rainy summer, greening the fields and the wild ryegrass for miles below. The current cleans silt-shallowed channels, moves the debris from the reservoir, from the mountain, down to the desert floor. When the rains abate, we hold the water back, to moisten parched fields later, in the heat of August.

July is haying time in the meadows. Haying goes on all summer, really. The rhythmic thrumming of the machinery through the yard is like the beating of your heart: tractors in the morning, swathers in the evening, balers thumping in the nighttime, when the dew is on the fields. Haying underscores the rest of the work, feeds the animals, provides winter pasture for all creatures. And the water feeds the haying.

A few days before haying, someone drives up to the reservoir to crank the big valves shut. The flow slows to a trickle, then stops. The reservoir grows benign, a place where children can be

Farm Sprinklers

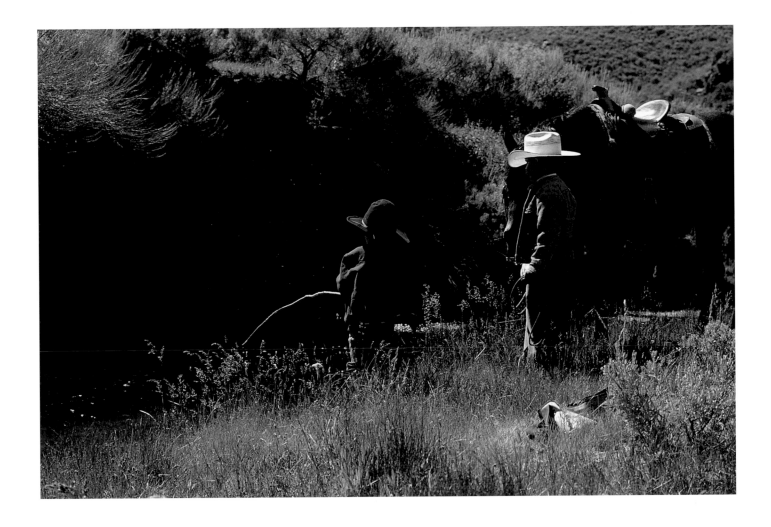

Little Fishermen

allowed to play, without fear of them diving off the dam and being sucked into the intake pipes, or having some other kind of disaster out here, too far from help.

Electric-blue dragonflies hover over half-submerged twigs. The summer hum of life is loud in the bushes. A coot squawks, exhausting itself in a mad flapping dash. We paddle with the children in little boats along the shore. We follow sandy fingers of the old channel upstream in the little rubber boat, into willow thickets where blue herons stand guard over immense rush-pile nests. Beavers work, severing branches, piling the willows into huge houses. In late afternoon they make v-shaped ripples in the still water, dragging the branches to their hideaway.

Desert people don't play in the water much. It has an alien quality, and even the fishermen mostly splash through shallow creeks, stay near the banks of these little reservoirs. There are fly fishermen on the bigger lakes up high, but for the most part, they're city people, not the desert dwellers.

SEPARATING SHEEP

It is September, and we are separating the sheep. Big lambs go to one pen, ewes to another. The big corral below summer sheep camp in Lovely Valley is filled with racket: dogs barking, kids playing, herders and sheep and the sound of wooden gates clacking open, shut, open, shut: ewe, lamb, ewe, lamb. They run down the long chute, and Grandpa heads them one way or the other. Dust filters through the dry aspens, leaving a fine powder on everything. The children are off in a corner of the big corral where they won't get run over, riding the ancient burro, Pete, the big jack who lives with the sheep.

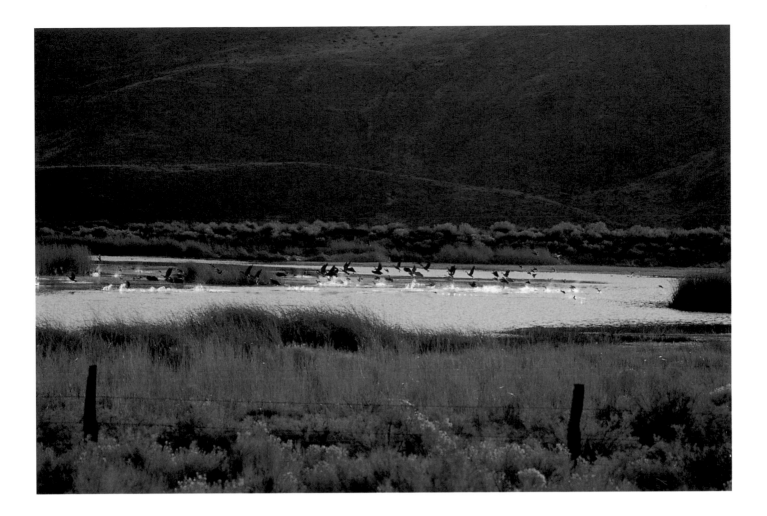

Waterfowl in Flight

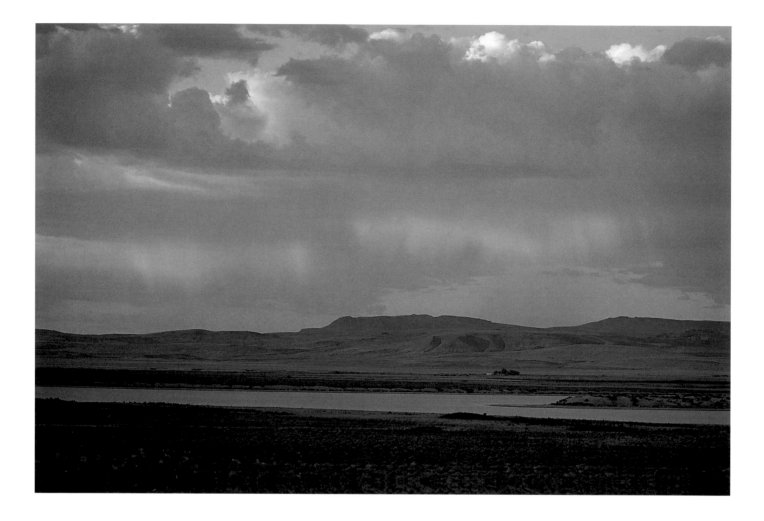

Tum-Tum Lake

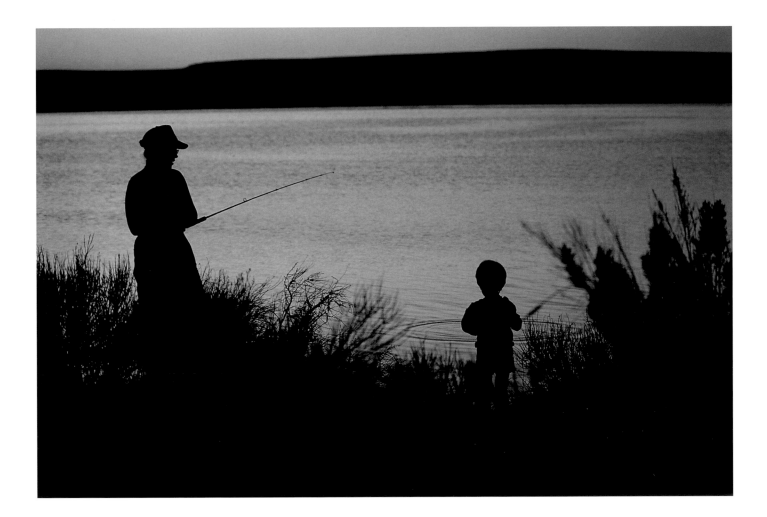

Fishing at Big Springs Reservoir

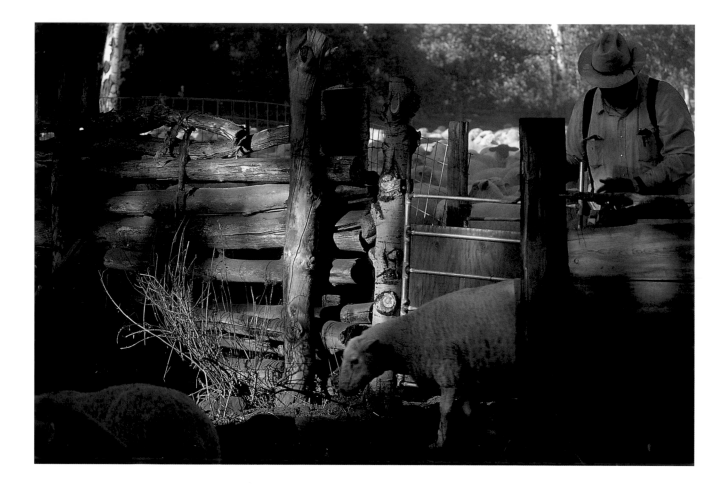

Separating Lambs

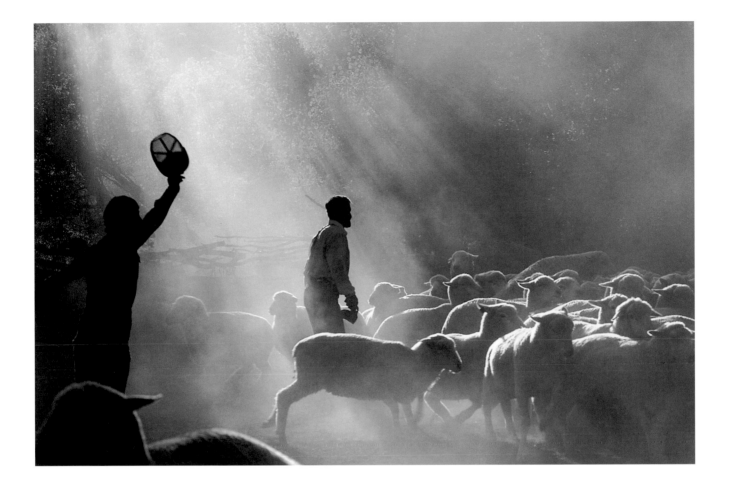

Sheepherders' Silhouette

Boys on Burro

Two boys and a girl, all under seven, pile one behind the other on Pete's back. They pull his ears, scratch his neck, hammer his galumphing old ribs with their little tennis shoes. He plods around the corral, around and around, for what must seem to him like forever. His patience is infinite. Almost.

The children never seem to tire of the game, but finally Pete comes to a halt in the shade of a big tree. He is immovable. He is the statue of a burro in the dappled corral, waiting for the pestilence on his back to pass. There is one more frantic burst of rib pounding, and the old beast's limit is reached. He unloads. One boy rolls right, one rolls left, and the little girl does a perfect backward somersault over his rump—but he is holding his hocks in check. He knows where her head is, and he does not take advantage. He is only irritated, not really angry. The three come screaming across the corral, their terror already turning into something else. They are puffing with pride and excitement: they have just been bucked off.

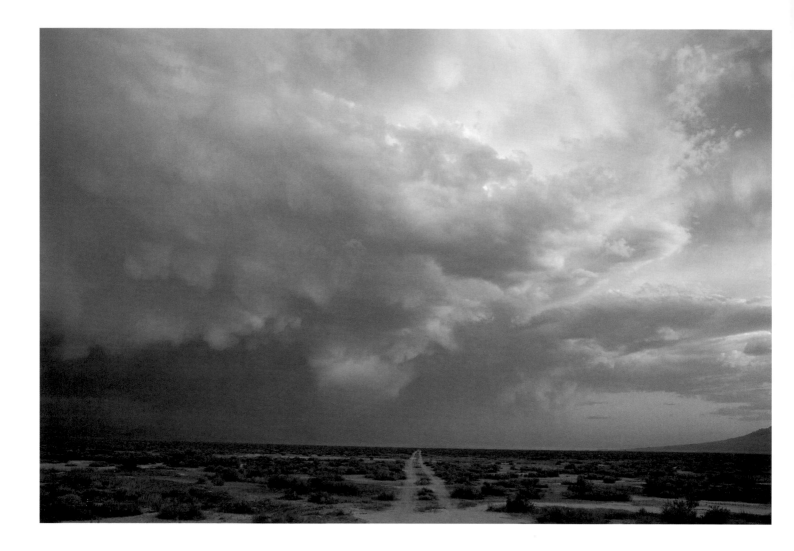

Road to the Storm

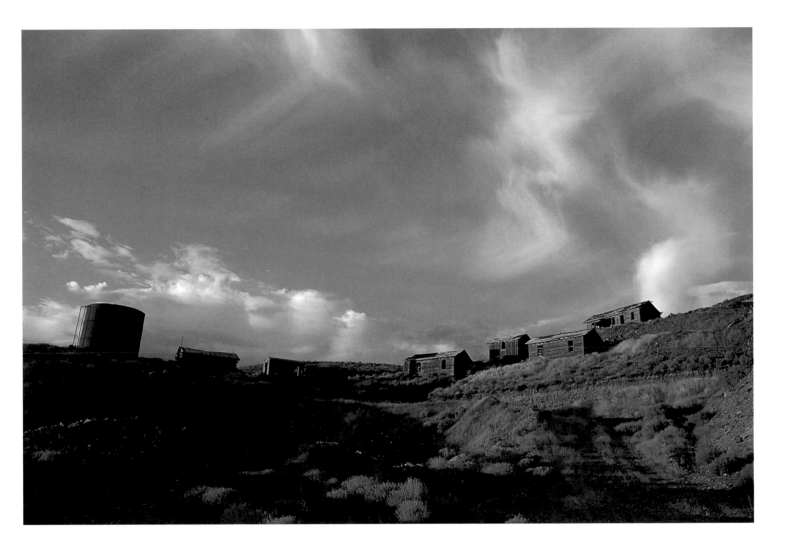

Jumbo Mine

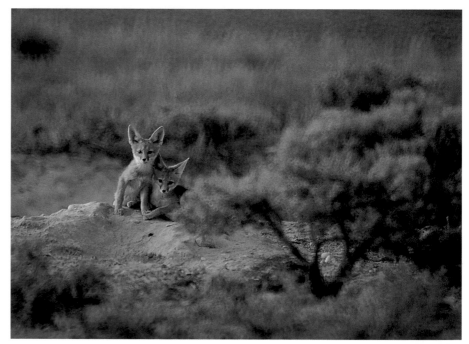

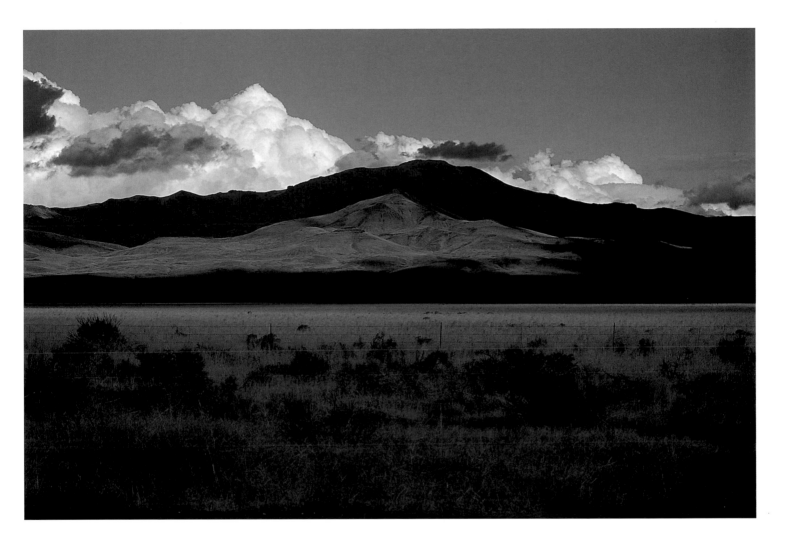

(facing page, above) *Free*; (facing page, below) *Littermates*; (above) *Mountain Shadows*

Northward

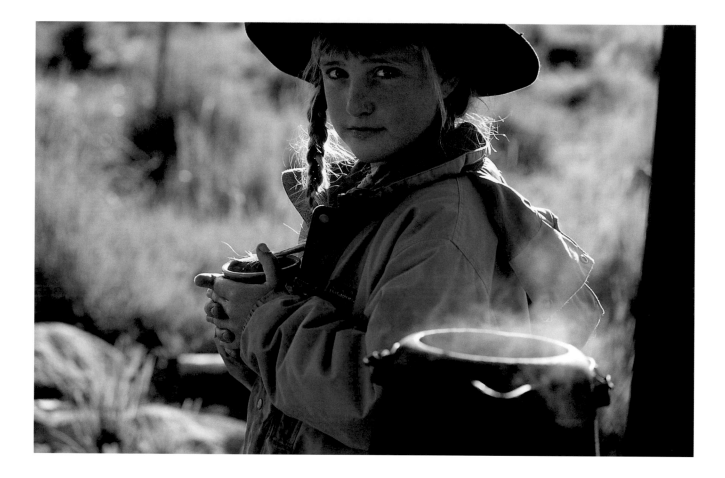

Camp Coffee

ECLIPSE

I first noticed when I went out to give the chickens the remains of last night's salad. They were sound asleep, flumping and muttering on their roosts. There was something wrong with the moon. Just a day after full, 3:30 A.M., and a fuzzy black bite was out of the pale disk. Of course, the moon was in eclipse.

I'm rattling up to sheep camp with Grandpa in the old flatbed pickup; the border collie rides between the saddles in the back. We drink coffee in the dark and watch the slow progress of the earth's shadow across the moon.

The shadow seems permanent. The sky is just barely bleeding into dawn gray, and we are catching horses before it finally moves away, leaving the fat gibbous moon to sink as we lead our mounts up through the trees to where we have left our saddles.

The gather is quick. Cattle hang on the dawn-side shoulder of the ridges; some are already down in the canyons at water. Morning ripens early into hot as we follow them up the road onto the ungrazed late-summer ridges, to keep them cooler and well fed, and to rest these lower hillsides through the last weeks of summer.

My tomboy niece, Magen, and I end up in the drag. She's thirteen. She has her own coveralls and spends her free time in the shop with her dad, or on a horse or on a tractor—anywhere but in the house. Her straight blond hair is pulled back ruth-

lessly, gold-colored braces; she has big hands, for a girl. She'll be a strong woman, one who won't give up her freedom easily.

One by one, the men peel off, to look for strays in this canyon or that. Magen and I crest the ridge on the sheep camp road, follow the herd down into the aspens. The mountain range is cored by granitic rock, mantled by red volcanic flows. Up here on top, uplift and erosion have revealed the mountain's heart. Lumpy spires build a maze of white rock easy to get lost in if you don't know the country. Aspen groves and little springs lace between the knobby outcrops. The undergrowth is dense, sprinkled with wildflowers even now in the late-summer heat.

We follow the cattle through the trees, around the forty-acre fence that defines the camp. Looking back from a high spot, I see the men coming along an easier trail, one that cuts across the steep hillside above the rocks and trees, but I like the way it feels following the big animals through the trees, hearing but not seeing them, bellowing to the calves, crushing leaves of wild horsemint, aspen leaves brushing my face and hair. We make it around all right, and the men catch us up with a cow and calf they've found. We wait for them in a patch of wild ryegrass, still green at this elevation. Dry iris seeds rattle in big pods, a sound just like a meadow full of rattlesnakes.

Grandpa comes along behind. He is on his own inspection tour. He has stopped to talk to one of the herders, nestled in a little grove of mahogany on a windy ridge. He has a radio for him, which we will drop off on our way out. The rest of the ride is easy, a little push across a windy eastern slope. We watch the cattle graze into the next basin, climb down off our tall horses, lazy for a little while in the late-morning sun.

We mount up, ride back into the trees. Unsaddle at the pick-ups and watch the horses shake their great shoulders, roll their shiny bodies in the dust to get the itchy places. They stand around for one last scratch, and then take off for the spring and the cool shade. Grandpa and his old dog and I rattle off down the hill.

The radio is in a box between my feet. The box is labeled MADE IN CHINA, tied with six strands of orange baling twine. We stop on the flat spot where the herder has his white canvas tent under a twisted mountain mahogany. The Chilean grins big when Buster hands him the box. *"Bailando y cantando,"* he replies to a question I can't understand. I'll be dancing and singing up here on my ridge.

BRANDING TIME

A generation ago, branding was a season-long movable feast of work and companionship that worked its way south along the mountain from Wilder to Log Cabin Creek, to sheep camp at Lovely Valley, to Nine-Mile at the south end. There were more cowboys, more families, more kids, more horses. Now the rhythm of the season has changed. There is still neighboring, but it is not like it was before the drift fences. We call around; get help from the neighbors when we can. There are fewer of them, more schedules to juggle, more men with other jobs.

There are two brothers who come to help at branding time. They grew up on a big family place out here, but now they both live in town. Louie is eighty, his brother Frank a few years younger. Louie is not a tall man, but his warm brown eyes glow with a quiet energy, and his tanned skin gives evidence of lots of time outside. A widower, he does his own laundry and hangs it

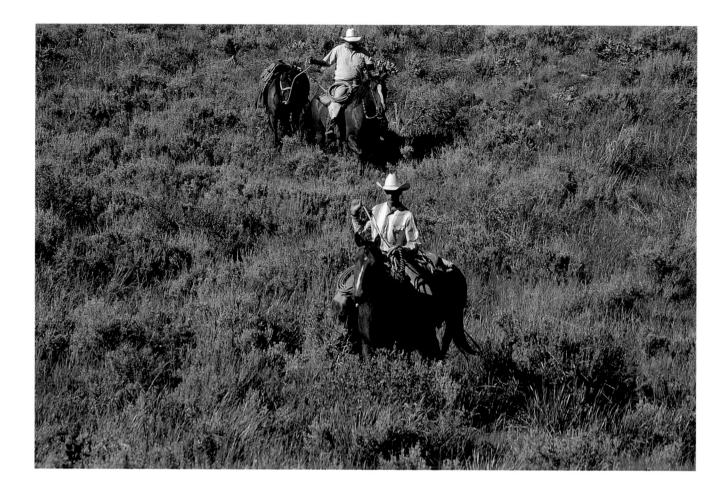

(above) *Bringing the Saddle Horses to Camp;* (facing page) *Cowboys on the Ridge*

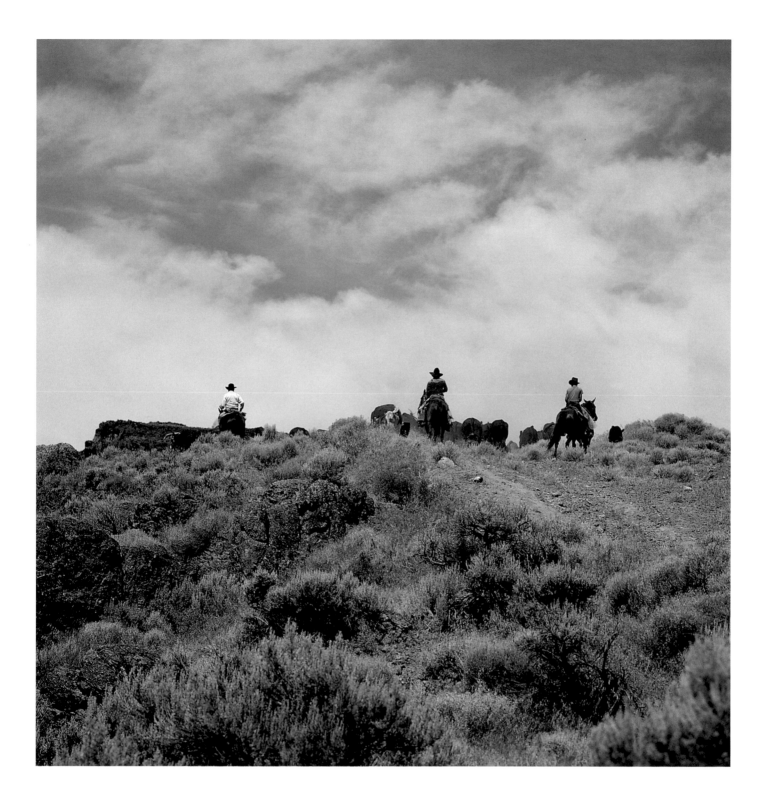

out to dry on the clothesline in the back of his place. Jeans and dark green work shirts wave in the breeze near the irises and asparagus. He still works on haying machinery and motors in the big metal shop out there. He jokes about the backyard, chopping down the weeds. People seek him out to fix their balers and their lawn mowers, and for his quiet way with animals, and for his stories.

He has lost a son in Vietnam, and a wife while he was off in Russia on a fishing trip, a once-in-a-lifetime chance to go fishing in Siberia with his brothers. There was no way to get in touch with them when she died. He has had trouble with his shoulder, and cataracts have bothered him. He has had a lot of reasons to give up. Maybe everyone who makes it to his age has had a lot of reasons to give up. "He can't give up, people won't let him," Tim tells me. They need his help, still. And we need his help at branding time.

He ropes for us, he helps on the ground. He works easily and without blandishment. He and his brother come whenever we ask. They're there at dawn or before, drive the seventy-odd miles as effortlessly as they seem to do everything else.

Barry comes too, when he can. A bachelor at forty, he sometimes rides for us in the winter and fixes fence, but branding is when we need him most. Tall, rangy, so quiet you don't even know he's there most of the time, "except when there's a wreck about to happen, and you look up. Barry's already there, makin' sure it doesn't." He's a magician with a rope, but he never rodeos, doesn't team-rope. Roping's not a party trick for him, not a competition. At branding time, when the kids are learning how to rope, he sits back quietly, letting them take their shots. They

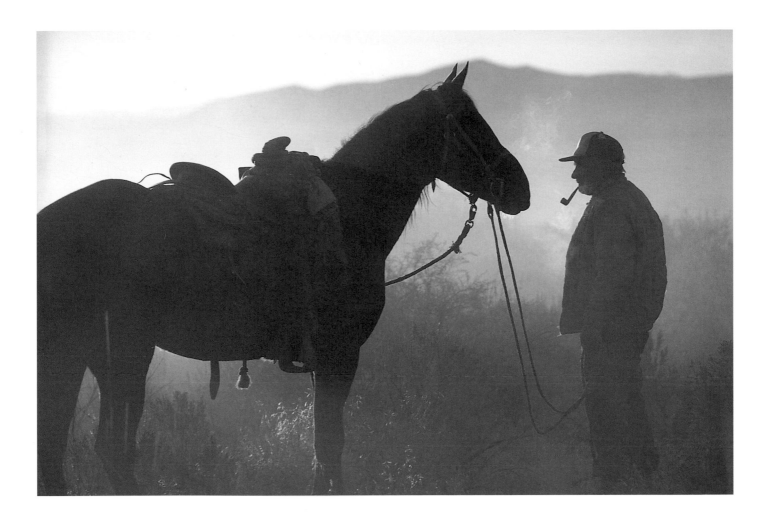

Early Morning Pipe

all miss, maybe a few grown-ups miss too, and Barry slides in, snakes a loop around the calf's heels. He never jerks the calf. He never wears spurs. He never seems to need them.

This hot June day, we are bringing a bunch in to brand in Lovely Valley, but first we have to push them up a cobbly dry drainage aptly named Black Canyon. From there, the cattle trail winds over a ridge and down off a steep side into the long green meadow where the branding corral is. It's a long drive, and by the time the cattle crest the pass, they're tired and cranky. The cattle bail off the hill into a deadfall-choked draw, full of old, blown-out beaver ponds. It's rocky and narrow. There isn't a good way to get down this slope, but there must be a better trail than this, I think. Dust powders the aspen leaves as we follow the cattle down through nettle patches and brittle mahogany, our horses clunking and stepping over the treacherous debris. Sam might have been ten that summer. I watched him take his sorrel horse over a beaver dam after a snorty black cow and her red calf. It's steep over there, and boggy at the bottom, rocky and loose above. Both the bog and the rocky hillside are a maze of fallen trunks and branches.

Barry watches with his full attention, gathered to help if it gets to that point. The kid's old enough to handle this. Well, maybe. His sorrel horse cracks branches, scrapes between boulders. He doesn't stumble, though, and carries the boy through the obstacles one at a time, black cow bawling ahead of him. They emerge, cross a lower beaver dam back onto the comparative safety of the main trail. Barry shakes his head. "Pretty good old horse," he says quietly. "Takes pretty good care of that kid." He moves off, and I exhale. I must have been holding my breath.

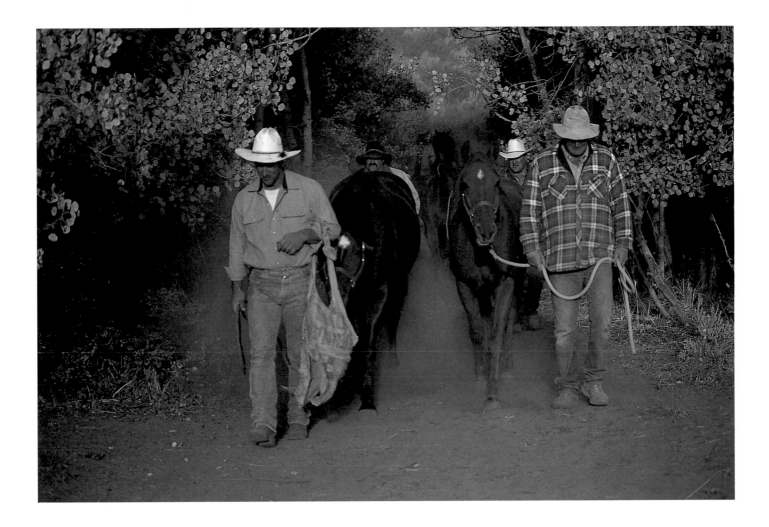

Cowboys Leading Horses

LITTLE WILDER

We leave Wilder in the dark in summer, trotting up the cool, sandy canyons in the blue half-light before dawn. Orion still hangs just above the black granite ridge. There is no talking, just the soft jingle of spurs and hobbles. Saddles creak, horses huff a little with the climb. By the time we're halfway up the canyon, the sun fires orange across the pass still far above us, throwing the boulders into sharp relief. We are strung out along the trail now, hurrying through thickets of head-high wild rosebushes and thistle. When we top the pass, Tim swings down, loosens his cinch, and resets the saddle. The kids and I do the same. There is still no talking, really. He swings back up, leads us around the contour of the big basin, shaped like a huge upside-down pyramid has been pulled out of the top of the mountain. The peaks here echo the pyramidal form. Trident Peak, Black Diamond, are the positive to this basin's negative, standing against the morning sky. We trot across the pyramid's north face, still in shadow, and into the warming sun of the skyline ridge. Indian paintbrush, penstemon, phlox, something flowering low and yellow, are tucked between low sage and boulders, thriving improbably in the porous granite sand.

Lupine lies like blue smoke on the hillsides. The boulders in the basin grow like a stone garden out of a field of yellow sunflowers. Water flows through wild iris meadows dry for ten years. The delicate scent of wild roses mixes with the strong smell of sage. The road is steep. We split at the ridge. Tim takes the long circle to the right, the young hired hand, Jose, the shorter circle to the left. My young son and I poke down the canyon in the

Wildflowers and Sagebrush

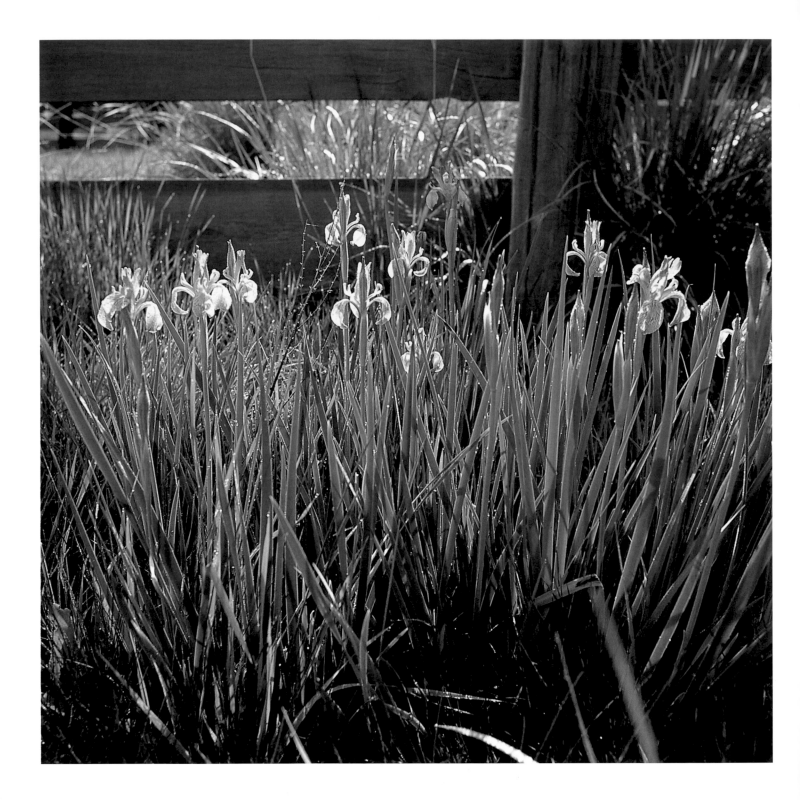

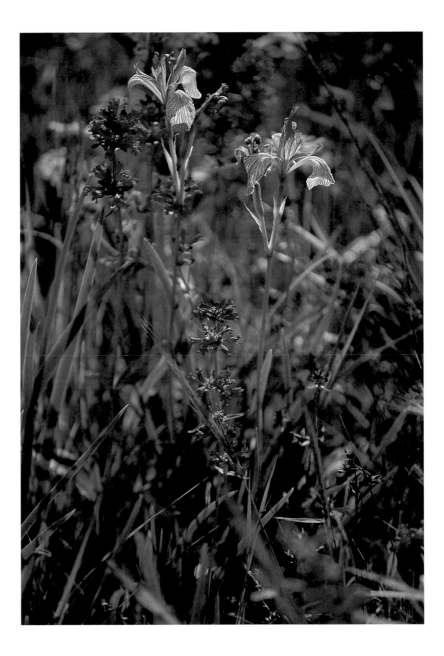

(facing page) *Wild Iris;* (above) *Meadow Wildflowers*

sunshine, instructed to stay high enough to see what might be sent our way down the steep side canyons.

Kids are always finding treasures in the wilderness, even the wilderness at the side of the road. Sam has found a chunk of opalite: he is certain this will lead to fortune. He has found an ancient Paiute village on the backside of Continental Lake: which government archaeologist is best to trust with his precious information? (We pretend a full excavation, a city of ancient travelers, documented and mapped, for certain, for sure, and only then shared, sparingly, with the appropriate parties.) Each quartz pebble carries gold; each chunk of obsidian is pregnant with history.

Time passes in the slow summer morning. There are four bunches of cows on four separate ridges. They are infinitesimal, wavering in the heat across the basin. They are not moving. The biggest bunch all face uphill, an artifact I will later recognize as full of meaning. But on this day, I am a child too. I see the border collies first, raising a dust. One circles the animals, goes to the head of the bunch, to keep the leaders in check; one is behind, to keep them moving. The animals move at first like a cloud, sluggishly; then they are a stream across the hillside. I realize we are in the wrong place, too far up the canyon to meet the leaders when they hit the road at the base of the hill. The string slides like quicksilver down the slope, turns at the bottom, where I should be, and heads up the next draw. Tim is far behind, uphill. He won't even see them until they've made the turn, a quarter of a mile down the steep and rocky slope. He doesn't say much, just goes back up after them. It's another hour into the morning before he can get them all back to where we are.

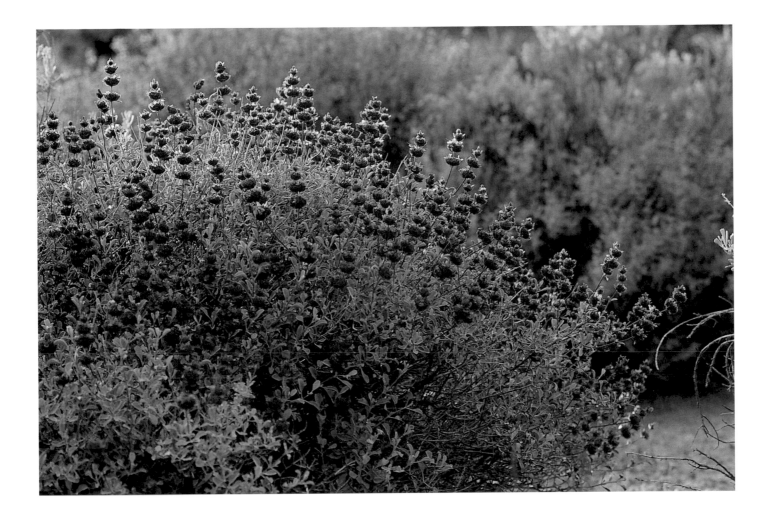

Purple Sage

The next time I have it figured out a bit better; I'm on the right piece of topography. I manage to turn a handful of wild-looking high-horned black cows back to the main bunch, although I nearly dash right on past them in my panic to get ahead. Finally they are all together at the bottom of the basin, and ready to trail, through canyons that twist back on themselves and wind upward through sharp volcanic outcrops.

It is a never-ending traffic jam in this narrow canyon, cows bawling for their calves, calves bawling back, unable to see anything in the brush and welter of bovine legs around them. Slowly they find each other, and as they do the leaders turn up the canyon, to the spring they remember from years before, to the high ridges where the bunchgrass is thick and the breeze keeps the flies at bay. We wait patiently for the mothering-up process to work itself out. We make the suggestion, by sitting here horseback, that up this canyon is the best place to go on this day. If we push them now, too many calves will end up in the rear. At the slightest provocation, they can turn like a gang of maniacs, take off pell-mell for the last place they have nuzzled their mothers. We would lose the whole day in five minutes, and spend another day just like it, probably tomorrow. So we take our time, poking along until the animals reach their summering place. Snowbanks still nestle on the north slopes, and deer brush grows where they have melted off.

We ride home slowly, horses tired, back up to the pass and across the slope and down the canyon to the bottom of Maggie Creek. It is late afternoon when we turn south onto the foothills. Thunderheads boil over the broad stretches of cheatgrass turning red above Wilder's stand of Lombardy poplars, still miles distant.

The summer wind dries sweat on my forehead. We have ridden up and down through 3,800 feet of topography, to the top of the mountain, and up and down through thirteen miles home.

Until recent years, the Quinn River cowboys moved their bedrolls and their tack thirty miles north of the ranch headquarters to the buckaroo camp at Wilder Creek in summer. Like many little homesteads in Nevada, Wilder was absorbed into this bigger place, during World War II.

Wilder is tucked into a swale between two fault blocks, invisible from the highway. There's no phone, no TV, no plumbing. One radio station comes in from Boise or Alturas, depending on the weather. Lombardy poplars surround the remnants of a good-sized orchard, which in turn surrounds the rock-walled, white-washed bunkhouse snugged down behind old lilacs and silver poplars. The dinner table, a big spool from the power company, sits under the trees.

Trees are the only evidence of many of the old homesteads in Nevada, Lombardy poplars planted for shade and windbreak, fruit and nut trees for food. A century later, most of the houses are burned down or packed off—there isn't enough excess building material in the desert to warrant historic preservation. An isolated apricot grove planted below a spring, a single black walnut tree near a creek, may be the only evidence that anyone ever lived and died here in these isolated canyons.

There are two orchards at Wilder. A twisted, ancient grove of half a dozen green apple trees in the horse pasture bore fruit when my husband's grandfather Alex bought this place in 1911. The young Basque from Errazu in Navarra herded sheep for some years. He had finally made enough to sink it into a place to

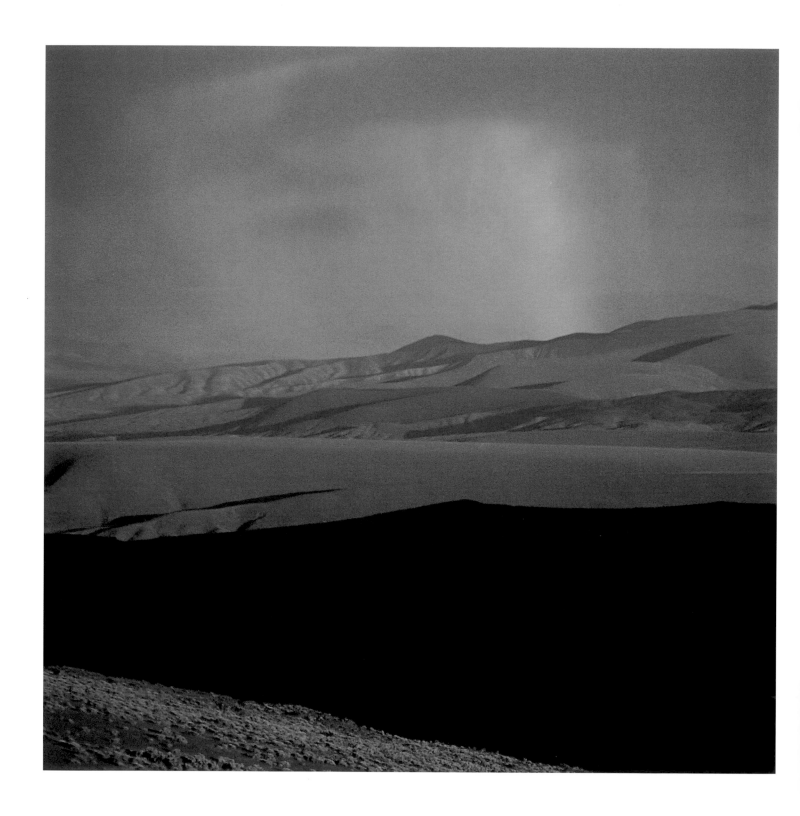

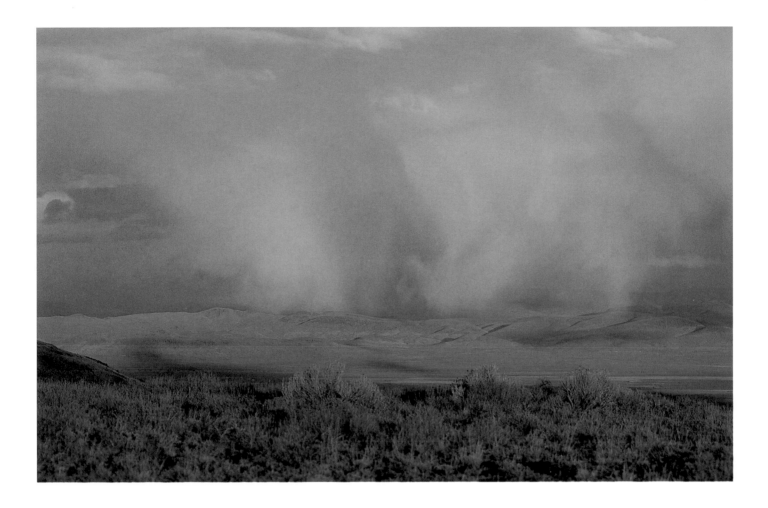

(facing page) *Rainbow over Pueblo Mountains;* (above) *Desert Storm*

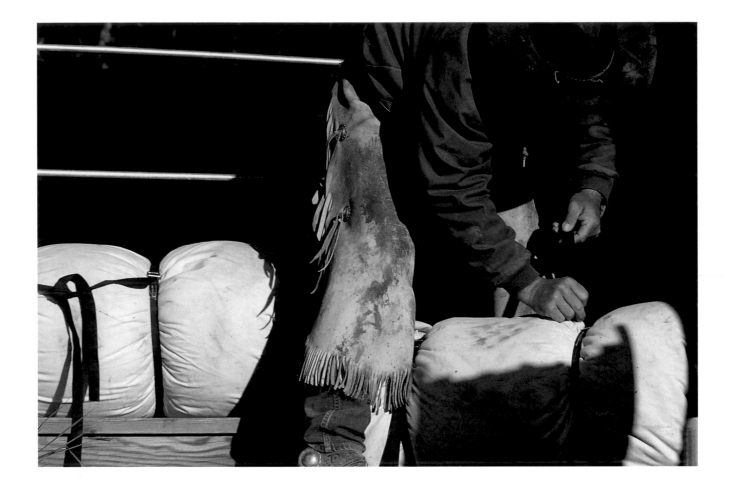

The Bedroll

Evening at Wilder Ranch

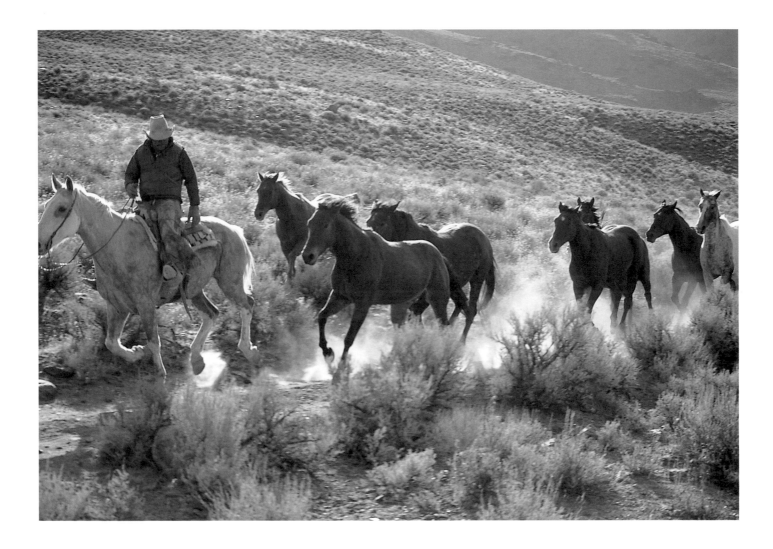

Cowboy with Saddle Horses

call home. He planted the big orchard, around the stone bunk-house. Cherry, apple, pear, plum trees grew from the porous granite soil. A stream flowed through the orchard, from a ditch dug into the shallow soil in the canyon, shoveled out each spring three-eighths of a mile so the water could run into the orchard, the hay meadow, the homestead.

After the war, after his accident, the little ranch sold, and sold again. Dry years and years of tumbleweeds choking the ditch shrank the flow of water coming to the homestead. Rains washed out the ditch altogether. Now the cowboys come up just for a few days at a time, during branding, or to ride the high country. They water the trees that are left, two pears, an apple, with a hose, a shovel, a bucket. The old orchard in the horse pasture is still alive; the horses sleep in the shade under those gnarled trees all summer.

Some days, time rings like a tuning fork in this place. The clarity of experience echoes across the generations, the rhythm of the work calling shadows across the years.

AUGUST 1939

The boy squinted into the morning sun. The steers had lined out pretty well, and the clicking of their hoofs on the trail filled the morning silence. He could see his brother and Ray, the hired hand, through the dust, far ahead, one on each side of the lead down the long sagebrush slope, pointing to the place across the valley where the trail disappeared, around the black hump of mountain, along the foot of the Pueblo Mountains.

All through the morning, into the heat of the summer, he trailed the steers across the green-gray ocean, down the flat,

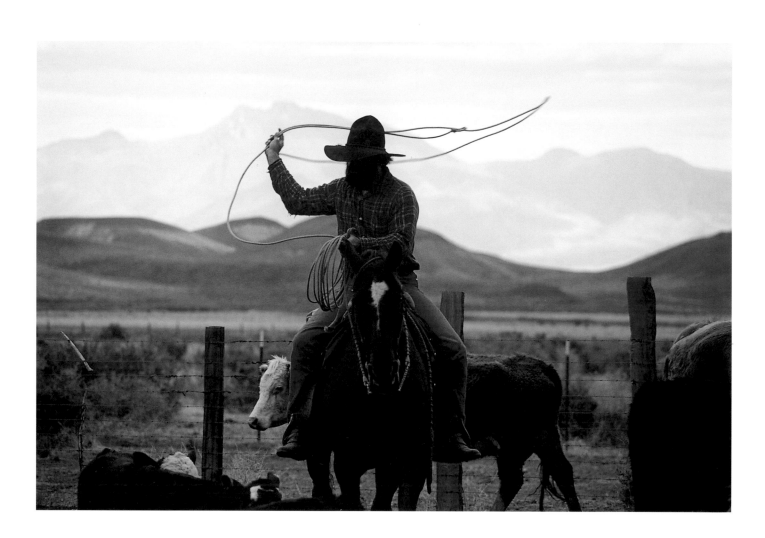

Roping

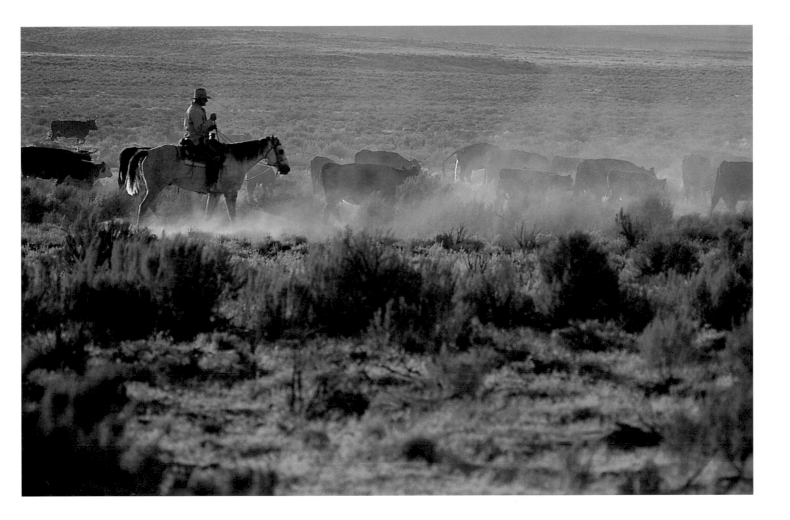

The Cowboy

around the treacherous boggy edge of the playa lake. Steers could get stuck in there, trying to get a drink. He hated to think of going in after them, for fear his horse would flounder, come back over the top of him in the sucking gray mud. Accidents happened, he knew that even if he was only eight, and you had to be careful all the time. It was a long way to town.

At least he had got his rig fixed up. They had ridden up Wilder Creek canyon the day before to the King's River side, over the top of the ridge to where you could see down into the valley where his uncle's place was. The sheep were in the high country, and the herders and the cowboys could always get a bite to eat and catch up on the news at Manuel's sheep camp, up there in the aspens by the spring. It was about the only way to get news out there then.

Manuel and the other camp tenders had made sure his cinch was good, and that he had a new latigo and new stirrups. They had been with his Uncle Tom since he'd had the sheep on the Refuge, before there was a Refuge. They took care of the boy when they could, fed him and made sure he had a dollar in his pocket when he went to town. There were cowboys from the King's River side up there at camp too, and they were all pretty serious and talking about something bad that had happened to his uncle. Tom had just been there, at Wilder, the week before, helping them finish up haying, seeing the family. He had let the boy tag along with him, be his helper. They would have talked about the horses, because they always did.

The boy made it around the edge of the lake, his brother far ahead, turning the lead. No steers got stuck. His brother was thirteen years older, a generation older, the chief of buckaroo

camp. The boy kept the drag moving in the dust and the heat, around the point, over the low pass, into the next valley as the sun crept higher in the sky, to the hot-spring-fed meadows where the steers went to pasture. The black flies were terrible in summer, driving the horses crazy, swishing and stamping, driving the cattle crazy, driving the boy crazy too.

They reached the meadows, turned the last steer through the gate. The boy's brother nodded as he brought the big gelding through and closed the gate behind him. "Stackyard fences need fixed," he said. The boy nodded. He climbed down, hobbled his horse.

The stackyard fences were taken down each summer at the beginning of haying time. Not the whole fence, but both ends of the rectangle where the workhorse teams dragged the buck rakes full of hay to be stacked. The heavy juniper posts had been pulled out at each end, and the postholes filled with meadow hay to keep the horses from sticking a foot in the holes and breaking a leg. Now the haying was done, and the fences needed fixing. The boy was down on his belly with his arm down the postholes, digging out the packed hay and smelling the sweet earthy smell of it.

There was a shack there, where they kept the fencing tools, and some cases of canned food. They opened a can of tomatoes for the boy, and he ate them in the hot shade straight from the can. He probably could have had a plate if he wanted to wash it.

Together they reset the posts, tamped them in, and restrung the wire. He brought the coffee can filled with staples from the shack so the men could hammer the wires to the posts, closing in the big, loose stacks of hay. The steers moved across the meadows in the lengthening afternoon. The wind picked up a bit, hot.

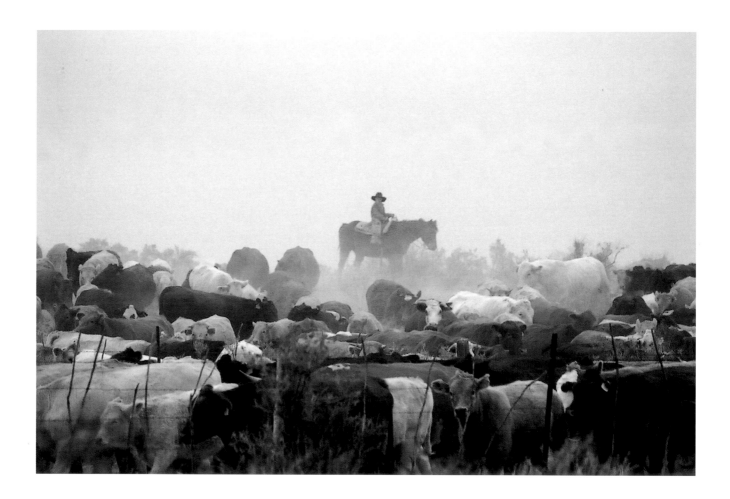

Dusty Buckaroo

McKenney Camp

He squinted west across the valley, at the white line of road that climbed the grade to the new refuge. The CCC boys were out there now, building roads and dams and fences to keep in the antelope. All the sheep were gone. Tom had moved the sheep and the horses and the family off the place and over into King's River.

They finished the fences, caught their horses. The boy followed his brother and the hired hand as they rode back the way they had come, into the evening, cooling finally, watching their backs as they talked and joked and finally rode in silence. Back over the low pass, along the foot of the red mountains. They rode into Denio in the dark, light shining from the doorway of the rock building that served as a bar. The boy stretched out on a couple of hard wooden chairs. His brother and the hired man had some drinks, and then some more drinks, and talked about the war that was surely coming, about the wreck that his uncle had in the next valley, falling off that stack. He was a fanatic about his stacks, they had to be level and curved just so on the top. He had to be up there on top when that last shock of hay came up, to make sure it was right, and he'd finished a lot of stacks before, but something had gone wrong with this one.

Sometime in the night, they woke the boy up, his skinny legs raw inside his pants, and he stumbled out to untie his horse in the cold, crisp blackness of desert stars. "Mount up, Buster," the hired man said. The boy swung stiff legs up into the saddle, and followed his brother and the hired man off into the moonlight, up the long sagebrush slope to Wilder, seven miles over the ridge. He didn't remember getting home, or putting his horse away.

The next morning, early, his brother came to get him up.

McKenney Camp Barn

"Come on, time to take a bath." "A bath? Why?" He hated baths. "Going to town," his brother said. The boy's legs burned from the riding the day before, and they burned worse in the soapy water. It didn't feel any better putting his town pants on, either, with the Metholatum or whatever it was all sticky and stinging inside.

The old Buick bumped and rattled down the gravel road. It was a hundred miles of rough road, and he slept most of the way through the morning on the way to town, waking up now and then to look out and ask where they were. And then he was in the big house in town with all the family. His mother and father and his aunt and the cousins already there, dressed up and older than he was, across the street from the funeral home, and then the cemetery, to bury the uncle who would never have moved again anyway, paralyzed by the fall, the uncle who was good to him, who loved horses as much as he did.

After the funeral, they went somewhere to eat, and the boy sat at the edge of things, not really understanding. Then he got back in the car with his brother and the hired man, and drove the hundred miles of gravel road back out to Wilder, where there were animals that needed tending the next morning.

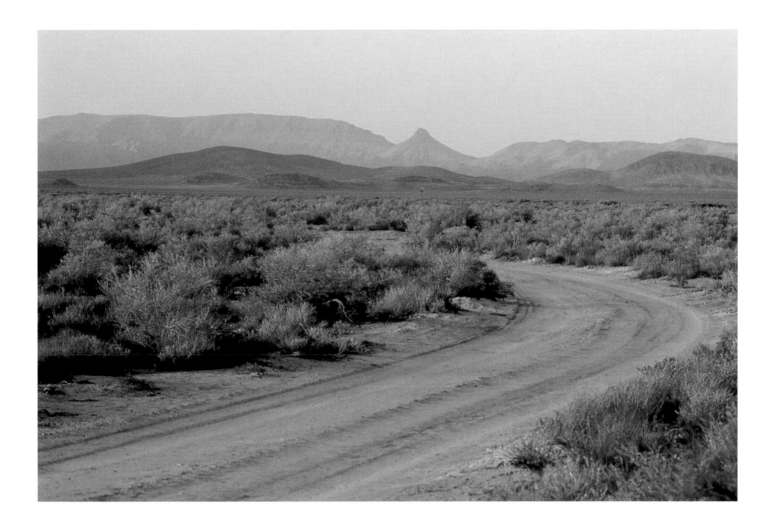

Road to Disaster Peak

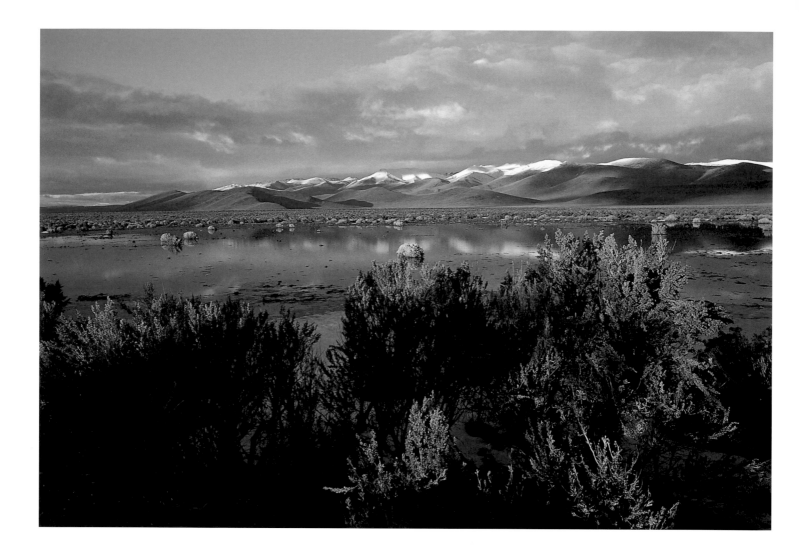

(above) *Desert Pond;* (facing page, above) *Hank Dufurrena and Horses;* (facing page, below) *Follow the White Mare*

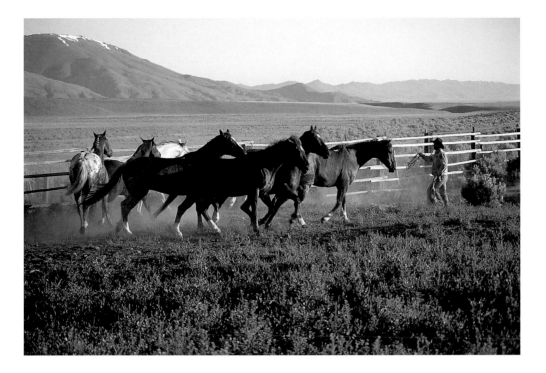

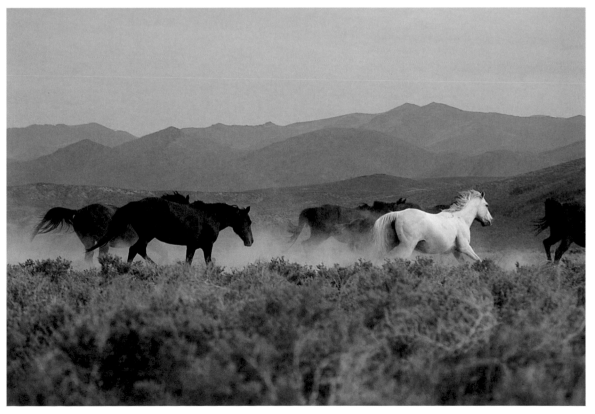

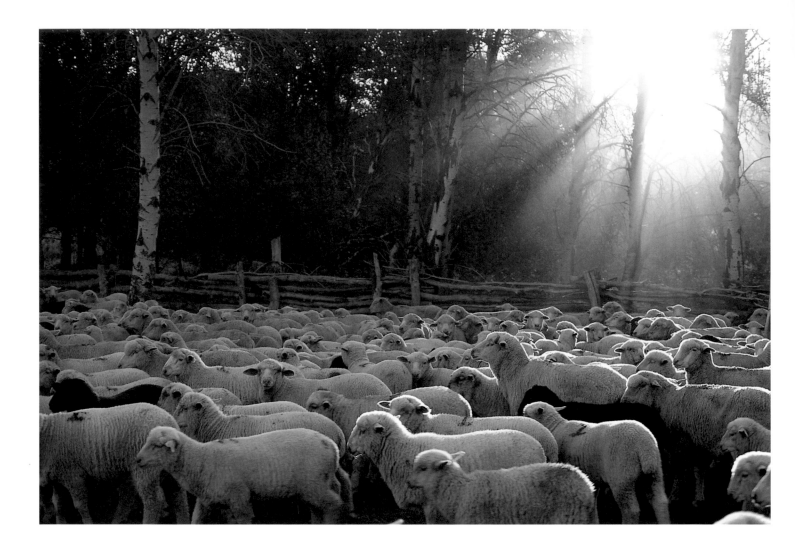

In God's Light

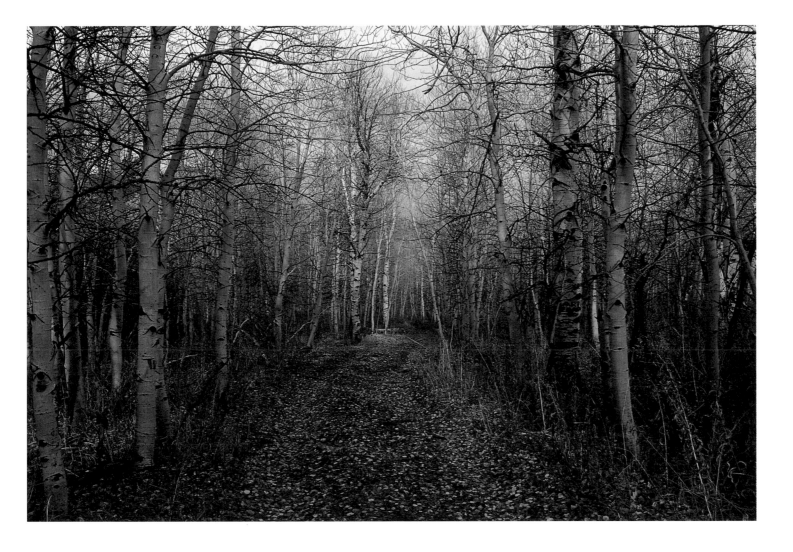

Winter Road

(above) *Indian Paintbrush*; (below) *Rice Grass*; (facing page) *The Light*

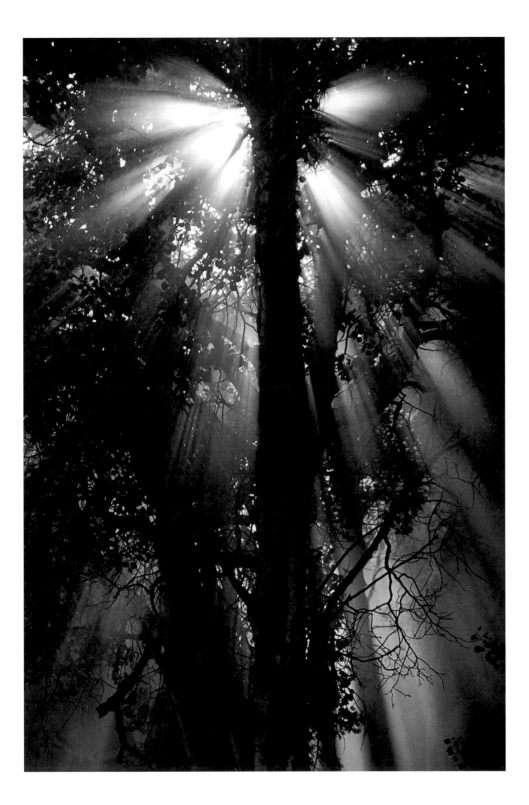

Westward

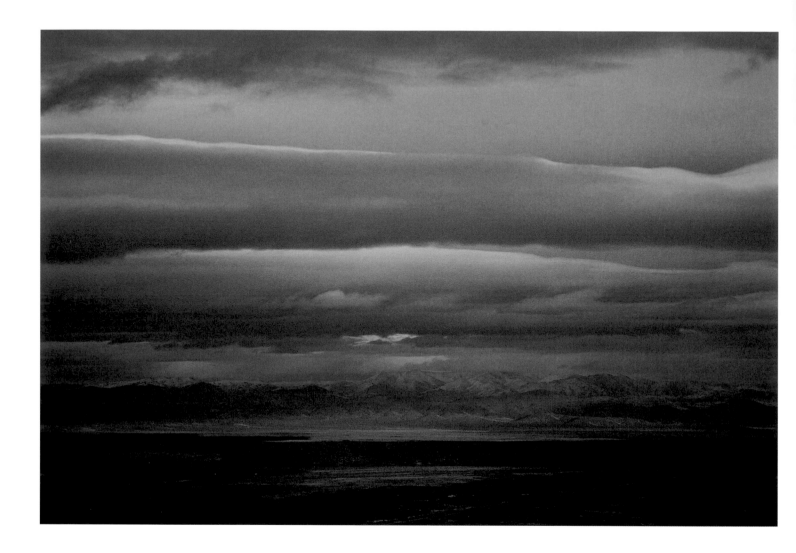

128 *Railroad Point*

EMPIRE BUILDING

The two-lane road climbs the steep rock face that defines the edge of that other country. Layers of volcanic ash, white, buff, orange, green, rise two hundred, then three hundred feet off the valley floor. There are only a couple of places to stop and look back. Traffic is hidden around the bend of the hillside, but if you look up, you can sometimes see the truck coming, or no truck coming, and then when you reach the wide spot in the road, you can pull out, across the downhill lane. From this gravelly spot, the whole edge of the Great Basin spreads out before you. The steep red wall of McGee Mountain arcs away south and east, ash flow roiling from vents, frozen forever as it rose from the earth. The narrow canyon of Thousand Creek Gorge knifes through the ring, a slice through a doughnut. Hawks float over its rugged walls.

The valley stretches twenty miles wide, sagebrush and bunch-grasses. Long black tablelands bound the north, as the earth healed rents with flows of thin black lava. It is the edge of the Columbia Plateau, the margin of the Basin and Range.

Rugged peaks, torn ridges of Basin and Range topography to the south meet that plateau country here, on this edge.

As you turn away, continue the journey westward, the climb takes you over the rim into a no-man's-land. A caldera moon-

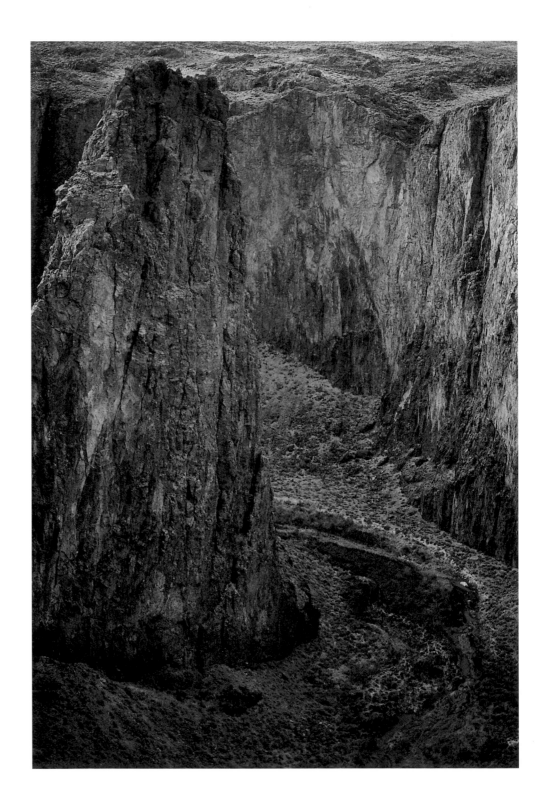

130

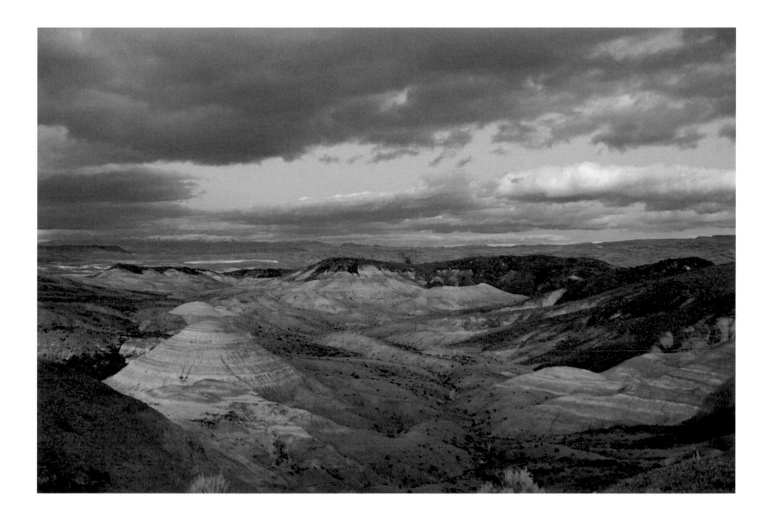

(facing page) *Thousand Creek Gorge;* (above) *Virgin Valley Opal Fields*

scape of sky and rolling rimrock cup the Virgin Valley meadows inside that ring of frozen rhyolite. Cold artesian springs caught in a string of ponds meander to the mouth of the gorge that cuts through to the outside world's valley floor. Warm water rises along the fault's arc at the valley's margin, still simmering from the eruption of twenty million years past.

The old red stone barns still stand on the meadows, reminder of the life led here before. Pink volcanic sandstone blocks, cut and quarried just here, behind this knoll, hauled by horses in wagons. Set, one upon the other, in perfect juncture by the stonemasons who built for eternity. There was a stone house, too, but when the government took this land for the Refuge, the house burned down. Now there is a nice doublewide near the site, with a porch, looking out of place with the ancient stone-work of the barns and the willow corrals.

In the official chronicles of the Sheldon Antelope Refuge, there is one sentence only. "The purchase of the Thomas Dufurrena properties were [sic] completed July 10, 1937, some six months after the official establishment of the Refuge." But there is more to the story than that. There always is.

It was the Depression. Times were tough, all over. Nobody would go by the ranch without stopping, friend or stranger, for a cup of coffee, a piece of pie. When times got really bad, whole families would arrive. The boy wondered what all these people were doing here, staying and helping. They didn't get wages, but they got food, and a place to stay till they got back on their feet.

The biologist from Reno was back again. He wanted the ranch, the meadows, the springs. "If you don't sell it to us, we'll have it anyway. This way you can get a decent price," he said to

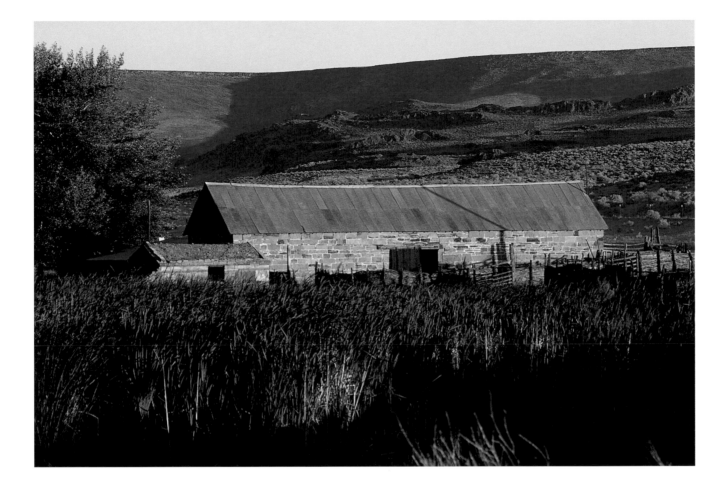

Stone Barn at Tom Dufurrena's Home Ranch, circa 1900

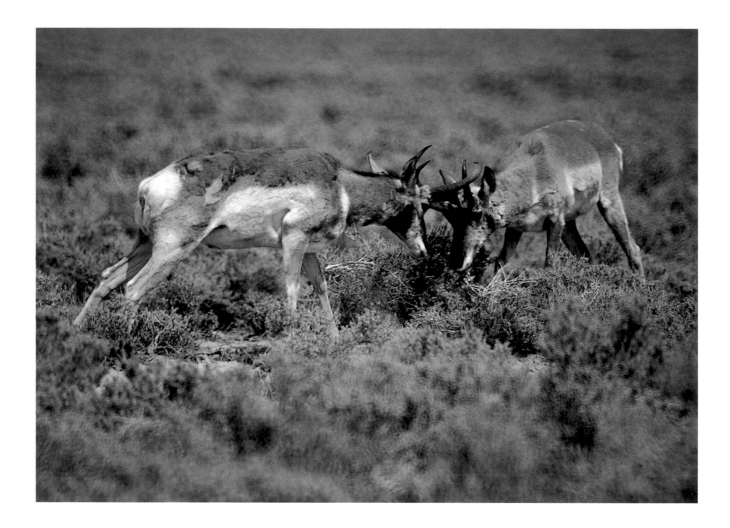

Antelope Playing

Tom. It had been going on for years. Sans had been coming to this empty corner since 1924, capturing the baby antelope, taking them to his yard in Reno. Raising them, sending them to Arizona, Montana, Nebraska. He was obsessed with this wild corner, and he wanted it. And he was to get it, eventually. Herbert Hoover created the Refuge in 1931. Five years later Sans moved out there, to another ranch that had already sold. He moved into the main house at the Hapgood Ranch, started building fence, putting up signs: KEEP OUT. U.S. BIOLOGICAL SURVEY. It was his empire, now.

CUTTHROATS AND CURTAIN HOOKS

It was blistering hot, late summer. The young men had been riding in the high rimrock, gathering with the neighbors. It was an old cabin so far back in the backcountry it was hard to believe anyone had ever been there. Four hours of dirty, rotten, four-wheel-low rocky track with the pickup from the home ranch, the home ranch a hundred and thirty-five miles from town. It would have been easier to ride a horse in there, and it wasn't easy to do that.

Done early one day, the boys hiked down to the bottom of the meadow to check the little creek that ran down through the rimrock and the canyons, to the sheltered valley far below. They knew they were there: the big, sleek red-bellied cutthroats that had slipped up this stream when the ancient valley lakes had dried, eight thousand years ago. And sure enough, there they were, hanging like shadows in the current, hiding under banks in the canyon choked with head-high sagebrush.

Some old fishing line was coiled up around the stump of an old willow plug in the homestead cabin, but there were no fish-

hooks for miles. The boys ransacked the place, and finally stood, staring, frustrated, out the window past the brittle curtain. The curtain, barely moving in the hot summer breeze.

One of the boys lifted a corner of the fabric. The muslin dangled from the rod on little, rusty upholstery hooks, the kind that stab into the back of the curtain, holding bunched cotton like dead flies to the wall. A little hammering with a rock, a willow pole cut from the clump at the edge of the meadow, and the boys were set.

They scrambled over rock falls and the dry piles of old beaver dams, twisting down the powdery trail between the steep red walls of rhyolite. Ranchers and sheepherders, so they said, had added to the stock of the desert streams in years past, packing barrels of three-inch fingerlings to the base of the canyon miles below here at the home ranch, investing in their future dinners and their grandchildren's recreation. There was argument about whether the two strains of fish could have interbred, somehow negotiated the boulder-choked chasm halfway down the drainage. The water didn't flow through on the surface anymore, but slid under-ground for stretches: maybe the cutthroats were pure. Maybe they weren't. Maybe there was an underground passage big enough for a slippery trout to maneuver beneath hot boulders, a cool dark fish trail to the valley floor below.

A nesting blue heron, startled by unfamiliar noise, flapped ungracefully off its nest. The young cowboys spotted the fish, bright in their spawning red, in the clear brown channels. They went to work, and caught enough for the camp for breakfast, siz-zling trout and eggs in a cast-iron skillet in the sharp-smelling

desert morning.

137 *Stanley Camp*

Lichen on Creek Boulder

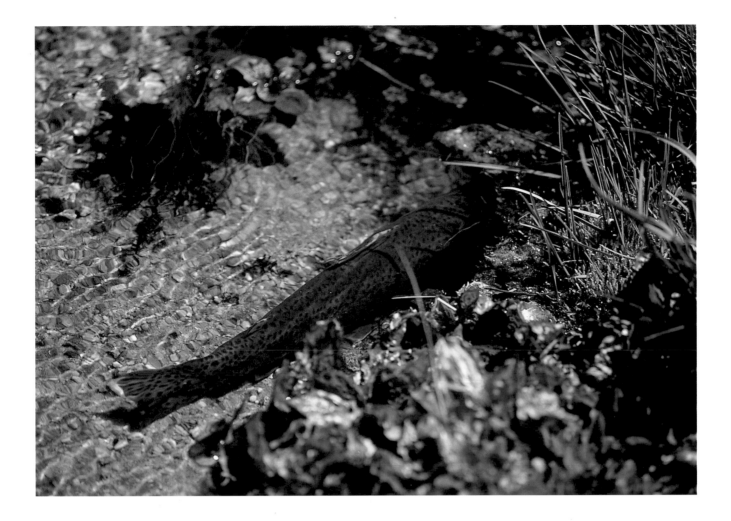

Fish in Onion Reservoir

In twenty years, this canyon would be choked with government fish biologists, who would capture hundreds of these fish and pack them up the canyon on their backs. They would carry the big fish in brown rubber wastebaskets on aluminum-frame packs, each bubbling with an oxygen bottle. Most of the fish would die. The survivors would be loaded into a big government fish truck at the top of the meadow and hauled through the locked metal gate to other streams.

The biologists would grind up certain fish organs (kidney, spleen, eyeballs are favorites) and break down the protein sequences with enzymes to make a kind of proteinaceous jelly, which is then spread on cakes of starch. When a negative charge of electricity is applied to the bread-and-jelly combination, the DNA strands respond by "marching across" the starch gel; longer strands don't go as far as short ones, and each species produces a characteristic pattern of bands—a fingerprint. Close scrutiny reveals divisions between species, and closer scrutiny reveals mutations within each species. Eventually they would prove that some of the fish that looked like cutthroats were not really cutthroats, that the rainbows somehow made their way through the boulder and brush piles below, and contaminated their cutthroat genes.

The biologists would then debate electrocuting the sleek red-bellied fish that had slowly evolved in that rocky canyon into what they were; they would rather plant the cutthroats' more pure cousins, hatchery-raised, to satisfy someone's idea of restoration. Along the way, they would buy this rancher out, so there would be no more casual cowboy traffic into this canyon, ever. They would close this stream to fishing so they could watch the population do

whatever it had been doing for ten thousand years, unassisted. But for now, it is just two young men, in the middle of nowhere, fishing.

ROLLER TAKES A SWIM

The grizzled Irish cowboy snakes the bay colt down over the rocky, brush-choked trail through what on USGS topo maps is called Bare Pass. Everybody around here calls it Bare-Ass Pass, because that's how it makes you feel. Merv has worked the colt down the headwall ridge, through the pine and mountain mahogany and the aspens to the quiet lake. He steps off in a grassy place under a black pine and carefully slips the hobbles around the colt's hocks, stretches and walks a few steps to the shore.

The high lake was left by glaciers. Lightning-blackened trees rim the cirque's headwall ridge, falling away to slopes thickly masked by pine trees, aspens, to granite boulders sunk in fine sand at the lake's edge. A skiff of long pine needles covers the narrow beach. The lake is dark green at midday. Light brocades the sandy bottom. Swifts skim the wavelets, hunting the afternoon hatch. The wind freshens. The cowboy breathes, lifting the terrible old used-to-be-white hat off his forehead.

There are more campers up here now, more fishermen. There are still cows here in the high basins this year, but in a few years that will change. A couple of fishermen eye him curiously, a figure out of a western novel riding into the twentieth century. One of them comes over.

"How's the fishin'?" Merv inquires politely, fishing his own can of Copenhagen out of a blue shirt pocket. They discuss the

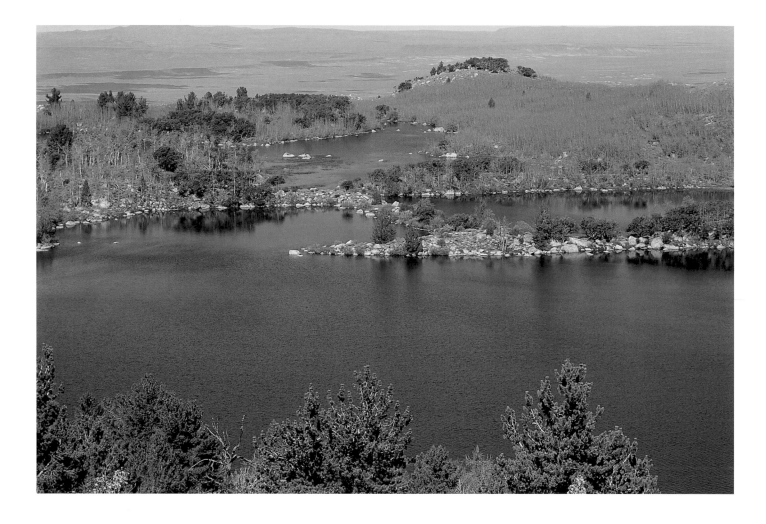

Blue Lakes

merits of angling in the middle of the day, dubious at best up here, shoot the breeze for a while. The fisherman says he'd better work his way around the back side. The colt is half asleep in the warm sun. As the fisherman passes, he smacks the colt on the rump. "Nice horse," he comments.

The horse comes to with a snort. Merv's eyes widen as the colt, still hobbled, takes first one, then two sideways jumps toward the lake. He moves as carefully as he can toward the colt's head, but the horse is panicked, and too quick. Next thing he knows, Roller has bucked himself, saddle, snaffle bit, and all, into the cold green water.

The glaciers have carved a steep profile into the basin, and the water is deep close to shore, the lake's margins boulder-strewn and irregular. The hobbles on the colt keep his front hocks close together: handcuffs. It would be easy enough for him to tip over and drown. The terrified horse lunges, struggling for his life. Waves surge from his shoulders as he heaves against the weight of the soaked saddle and blankets, the split reins tangling up around his feet. Merv can only stand helplessly on the shore, watching.

The colt's eyes show white. He snorts and coughs, kicks and kicks at the hobbles that keep his feet chained together. Finally, somehow, he breaks free. Power doubled, he claws his way up through the big, smooth round boulders. One final desperate heave, and he stands, dripping and quivering on the grassy patch by the lake's edge. Merv reaches out slowly, takes the reins, eases off the cinch and slides the sopping saddle to the ground.

He stands, silent, for a minute or two. "Goddam, Roller," he says finally. "Let's just take a little siesta while these blankets dry, and then ease on home." He looks at the trail leading up the

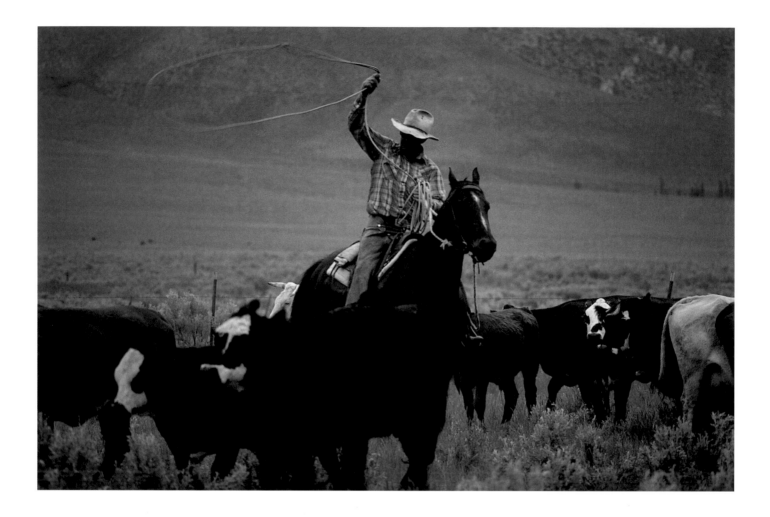

Merv Takacs Roping

headwall ridge, and sighs. Roller shakes his massive shoulders like a dog, and sighs too. He drops his head to the grass, and starts to eat. He's hungry.

Merv shook his head as he finished his story.

"That old Roller. I thought I was gonna lose him, by God. By God colt's got some heart to him, doesn't he?"

Ranches raised cattle all around the Pine Forest Range until the 1980s. The place where this day passed in 1984 is now a Wilderness Study Area, and there are no cattle here. Lots of fishermen from all over flock here in the summer and fall months. There will be no more opportunities for cowboys riding colts to meet fly fishermen at Blue Lake. It was a passing moment, two cultures just touching, before one slipped away into history.

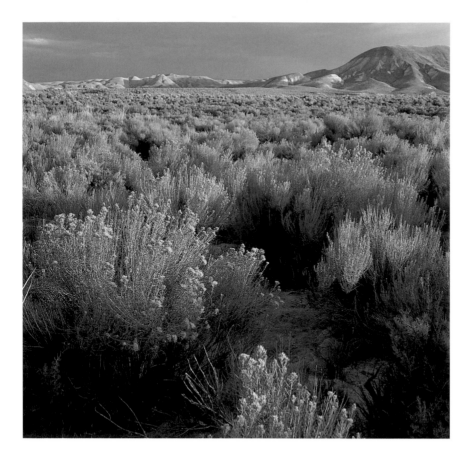

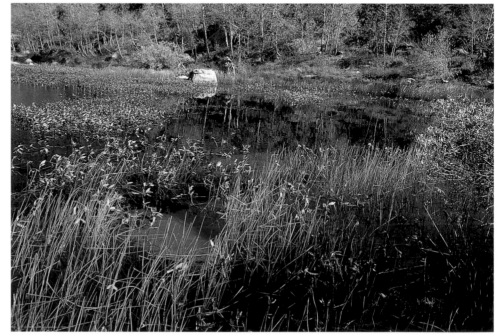

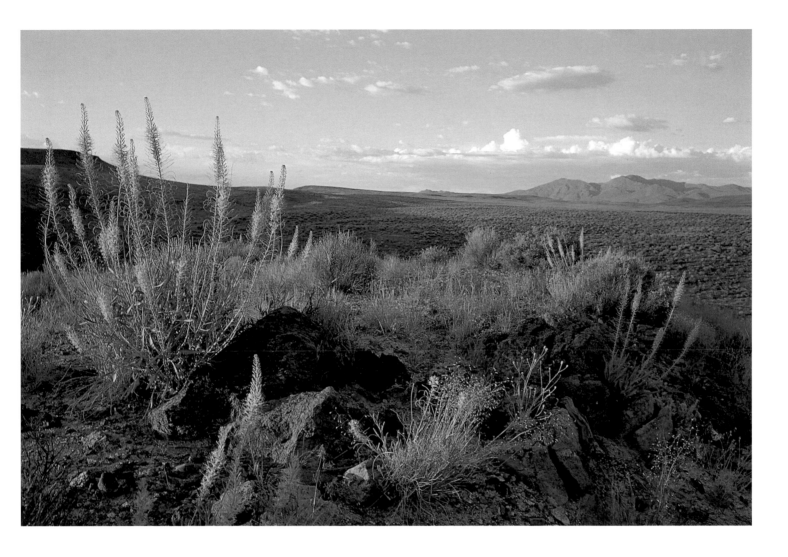

(facing page, above) *Virgin Valley*, Sheldon Wildlife Refuge; (facing page, below) *Blue Lakes Pond*; (above) *Prince's Plume*

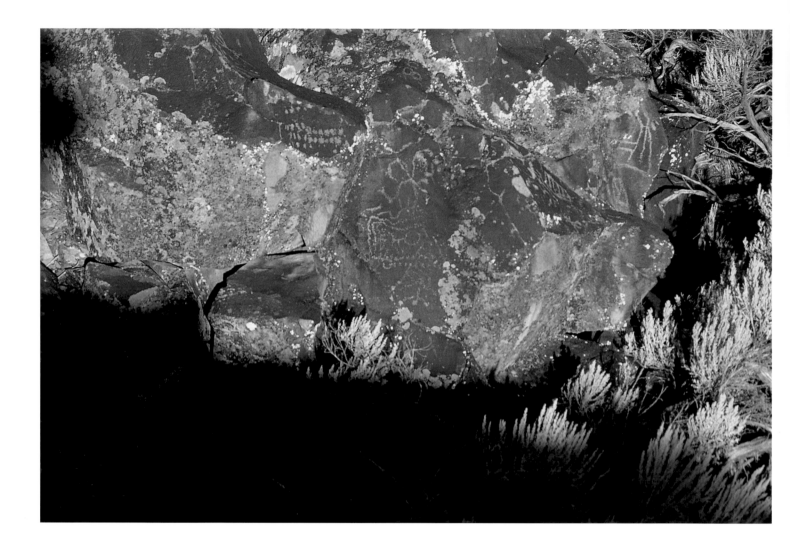

(above) *Petroglyphs*; (facing page) *Granite Creek Wallpaper*

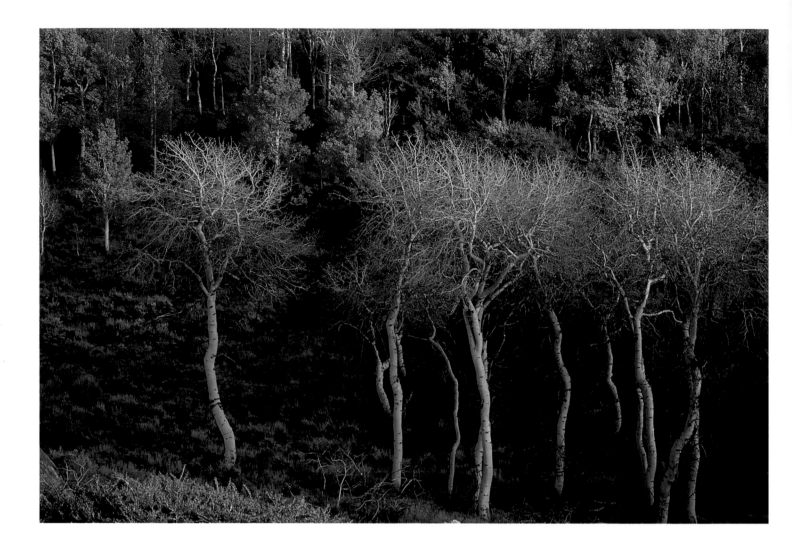

(above) *Fall Aspens at Little Onion Reservoir;* (facing page, above) *Aspens on Pine Forest;* (facing page, below) *Lone Aspen on Pine Forest*

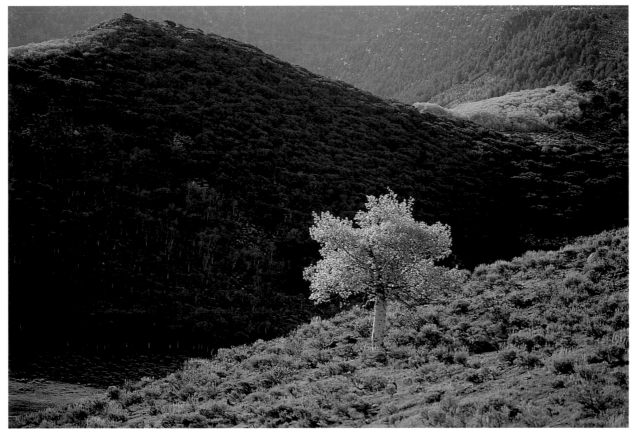

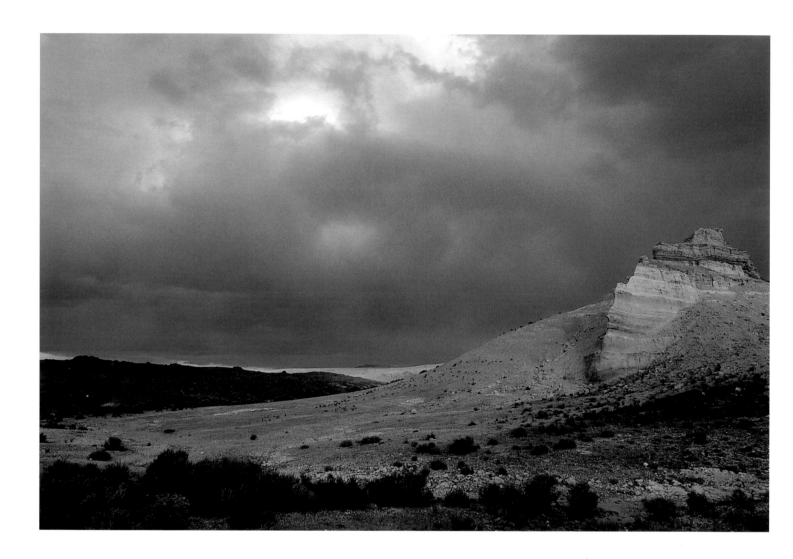

The Castle, Sheldon Wildlife Refuge

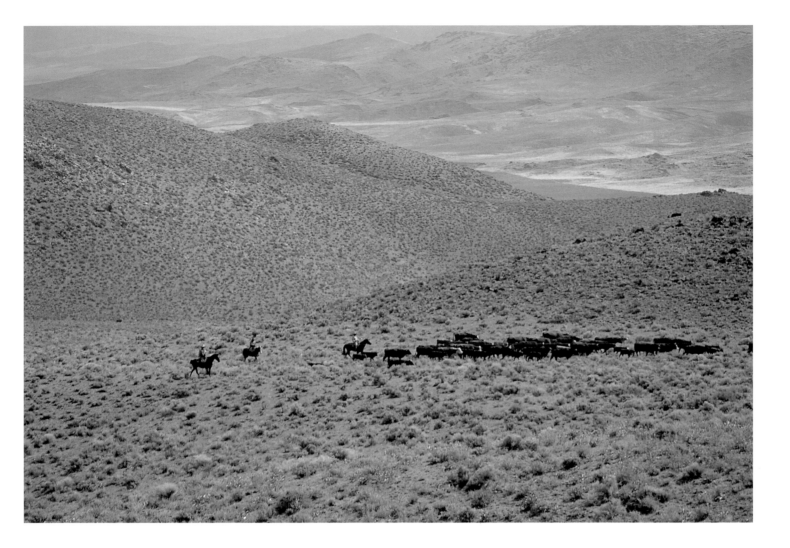

Gathering Cattle

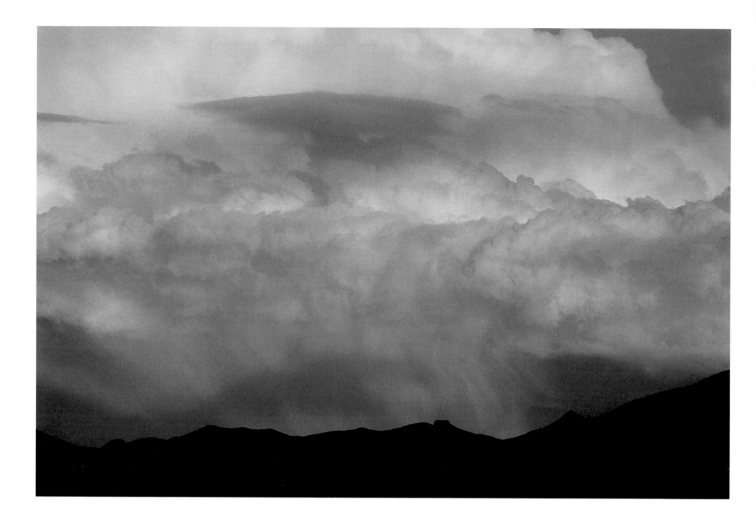

(above) *Majestic Clouds;* (facing page) *Stone Baby*

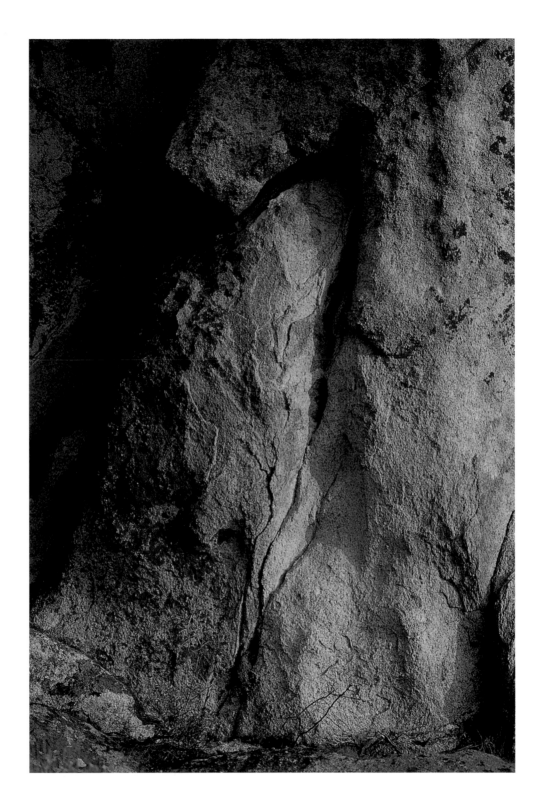

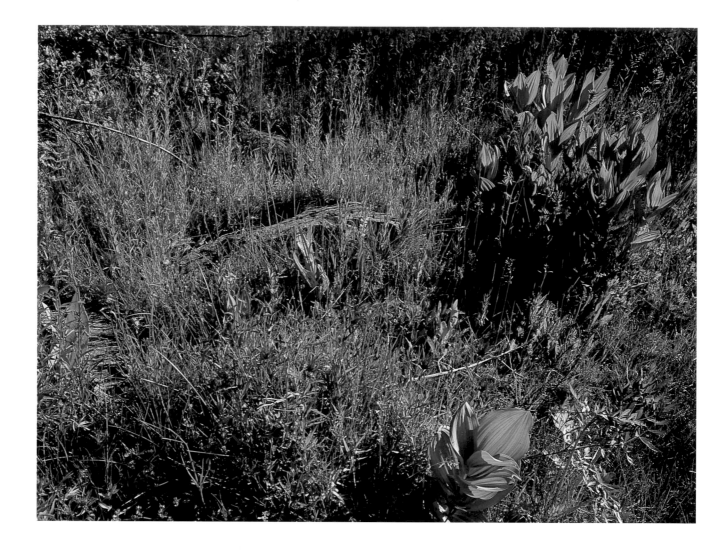

Wildflowers at the Spring

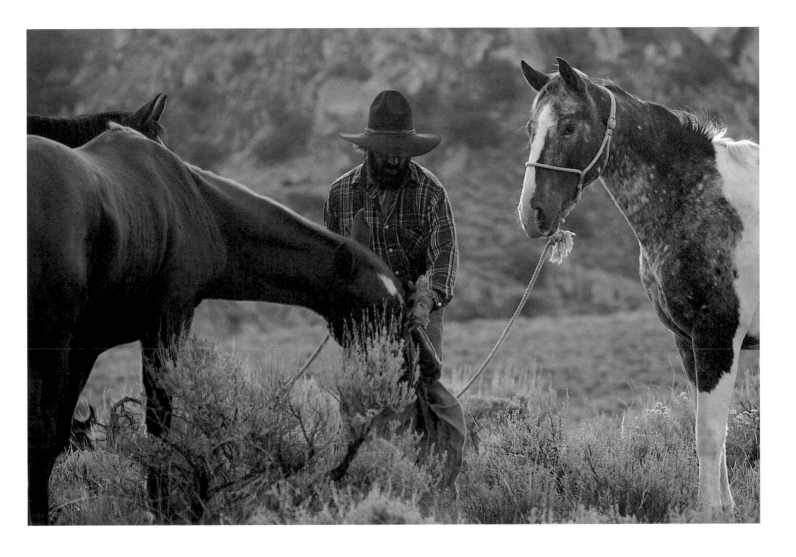

Early Morning Feed

(facing page) *Snowcapped Pine Forest*; (above) *Lake Reflections*

Homeward

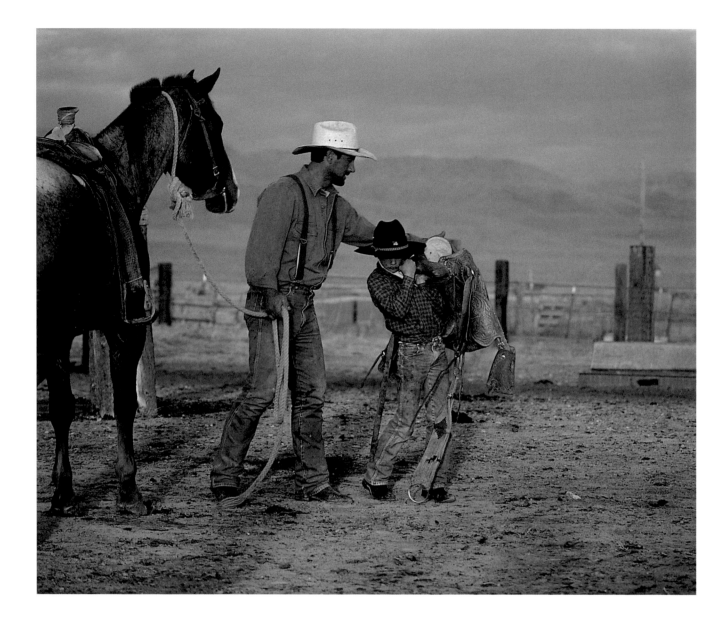

Dad and Son in Corral

PASSING IT ON

The wagon bumps along behind the tractor, down the morning
meadow. There is one new calf in the heifer lot, and the snow
is soft on the ditch banks. The brothers, Tim and Dan, stand
shoulder-to-shoulder, thighs braced against sweet bales of
meadow hay. The little boys swarm at their feet like puppies.
"Dad, can I feed now?"
 "Dad, can I chop?" "Can I hold the axe?"
 "In a minute. We're not there yet," says Dan. "And you'd bet-
ter hold on. Your mother may decide to go into fourth gear here
in a minute."
 Maryjo's hair glints auburn in the sun, as she turns around to
check the wagon's progress from the tractor cab. The boys' friend
Victor leans close to Ryan, the elder brother. "Hey, Ry, is your
mom a good tractor driver? I've never sat up this high on bales
before."
 "I dunno, Victor, I guess we'll find out," Ryan says to his
friend.
 The tractor rumbles along; no one falls off. The days are
lengthening. Winter may not be over, but its back is broken. The
cattle follow behind the wagon, which carries bales stacked four
layers high and tied with orange polyester twine. The brothers
lean into their work, the rhythmic chop-and-swish as flakes of

sweet grass thump to the sodden earth and hungry cows line out in the wagon's wake, munching their breakfast.

"Dad, Dad, let me go, I can chop," rails Josh, five years old.

"Not till the pile is shorter," his father replies.

The boys' friend Victor is happier after a couple of layers have been fed off the wagon. He and his buddies hang their feet over the edge, kicking loose hay from the back bales.

"Didja see the guy in the striped shirt at the basketball game yesterday? He ate so much hot sauce on his chili. It was amazing. He put Tabasco, and that Mexican hot sauce, and salsa, and salt and pepper too!"

"Huh. Mom says if Dad ate any more chili at the game we wouldn't hear the last of it for a week!" Ry responds with that unmistakable second-grade-boy implication.

"Dad, can we feed yet?"

"Almost," says Dan.

The last layer of bales is gradually uncovered. Skeins of orange twine pile up on the front of the wagon. A long wake of munching cattle stretches behind the wagon.

"All right, but be careful." Dan hands over the short-handled axe with one wicked hook like a raptor's claw welded to the backside of the blade. "Chop here, and here, and here."

Ryan takes the tool in both hands, a determined squint on his face. In a couple of chops he finds his range. The orange string parts, and the end of the bale rolls gracefully off the edge of the wagon. He turns the axe so the hooked side catches the grass, and helps the chunks fall onto the wet meadow. Victor and Josh are on the other side. Uncle Tim makes them take turns. Victor first, because he's older. The effort of pushing the flakes of hay is so

164

complete for five-year-old Josh that it looks like he'll launch himself with each push. But Tim has him firmly wedged between his long legs.

The boys get better slowly, discovering where to part the hay so the bale will separate at just the right distance from the end so that its weight will carry it off the edge of the wagon. Father and uncle hold the strings, and the axes, sometimes. They push the bales closer to the edge with their feet. They balance patiently behind the boys on the bumping wagon, letting the kids figure it out, keeping them from falling off, getting the job done.

There is no banter now. The boys work hard. Chop, chop, swish. A soft boy-grunt of effort is the only sound to be heard as the last bales fall to the softening earth. Then it is over, the last pile of loose hay scraped off the back of the wagon, the last skein of twine, wrapped and dropped on the pile in the stackyard.

Mom climbs down out of the tractor. "Wow, that was great, Maryjo," hoots Victor. "Better than the rides at Disneyland!" They pile off the wagon and race for seats in the back of the pickup. "I get the spare tire!" "I get the tailgate!" "No, you do not get the tailgate." "But you're on the tailgate." "I am waiting for you to get over on the tire." "But I called the tire!" The pickup bumps and rattles across the field. Voices fade into the morning, leaving the cattle munching and swishing, the snow softening on the blue mountains, the new season coming.

The children of ranchers know what their fathers do all day, because their fathers take them along. They teach them the tools of their trade and how to use them. I watch my son tie a knot with leather saddle strings, slowly, methodically, the way you do something before it becomes second nature. I've never seen this knot

before. His father has taught him. There are other lessons, some apparently trivial, some not: this is the way to coil your lead rope; work your horse through the herd this way. Gather cows across a flat like this. Never ride your horse through the bog after that one stubborn cow in the willows; get off and throw things at her. You might get in trouble here; go around the long way. Dad can see the places where trouble lurks. He's been in that bog up to his horse's chest, or his dad was once. The men weave a skein of knowledge and concern and jokes, punctuated by memory and the far vision that comes from looking down the long years on the land.

<p align="center">✸</p>

My husband is still learning from his father: where the pipelines are, how to siphon water from the pipeline into the upper trough, and then the lower trough, a mile away. The two boys, my son and his cousin, are fooling around a quarter of a mile away with the horses. Tim is down in a metal box that lies nearly flush with the ground. He is doing something with pipes, and cussing. He picks up his head, bellows for the boys; they canter over. He gives instructions, not explanation. Hold your hands over this opening in the pipe at the bottom of the trough. Don't let any water in. It looks like it feels good, up to your armpits in cool water, but the pressure is too much for young hands, stretched armpit-deep over the end of the trough. Bubbles escape; the air pocket in the pipe is still there. The water does not flow. We change jobs. (I have been holding horses.) It is hard for me to keep the hole blocked, too. Finally something happens, the water boils out the other end. The trough half a mile below fills.

Thirsty animals drink. We mount up and ride home. I have a picture in my head of black Visquine veins bringing lifeblood, underground, to dry canyons.

FAMILIES

Women's territory tends to shift with the age of children. When the little ones are old enough to begin to learn the larger territory outside the house, it frees their mothers also. Maryjo drives the tractor on weekends, but the rest of the time she's teaching at her two-room school in Oregon or helping a little group of preschoolers at the Denio Community Hall. They come once a week to learn their colors, how to count, how to shape their letters. Hank's wife tends goats and the leppy lambs, drives the book mobile in town, reads meters for the local power company. I try to cowboy on the weekends when I'm not teaching school, and I write about the desert. Linda teaches photography and sells her images of this life all over this country and Europe. It's all quietly about survival.

Our family ranches are disappearing as surely as the carrier pigeon, with less fanfare than the leopard frog. There are fewer grandparents each year, fewer ranch kids who can afford to stay, or want to. Life is not always kind out here. But families, working together, learn who they are, what kind of men and women they will be, determined by the hardships, and the joy, of living here. Every decision has a consequence, every mistake its price.

DESERT GARDEN

The tiny, white-haired woman scrapes the bone-hard ground with a hoe. A three-inch-deep indentation trails off behind her

tool as she readies her garden for the summer. The ground is hard gray clay; it holds a lot of water when it's wet, but it has all the qualities of concrete when it's dry. The rows defined, she plunks a hose in one end of the garden plot, watches the water snake around the little ditches. "We just plant right here on the edges of where the water runs. Then we block up the end of the rows with rocks," she demonstrates with a chunk of calichified basalt. The rock, the size of an irregular grapefruit, blocks most of the water in the row. The water backs up, barely submerging the shoulders of the soon-to-be-planted mounds. I look up at the hot desert outside the square of elm trees that shields the house. This is a far cry from the gardens of my Iowa childhood, three feet of rich black loam you could crumble with your toes. My boot scuffs the dry clay. She has shown me where her asparagus is planted; along the big ditch half a mile away, where it will have water all summer without drawing more water to the house than is absolutely necessary. This isn't so important now, but in years past it was.

"We lived on potatoes and onions for a whole winter. Trying so hard to make it work, trying so hard just to survive. Drove the cattle to the railhead in January, got seven dollars a head, had to shoot 'em yourself." This difficult an existence has to leave a mark, and it has. The ranch was the most important thing, it became more important than individuals, more important than family, and somehow, something got out of balance. The ranch survived, but the reason to keep it evaporated. The kids didn't want anything to do with it, after it was bought and paid for. Like the ground beneath our feet, capable of holding but not transmitting moisture, the ranch absorbed and absorbed all the energy

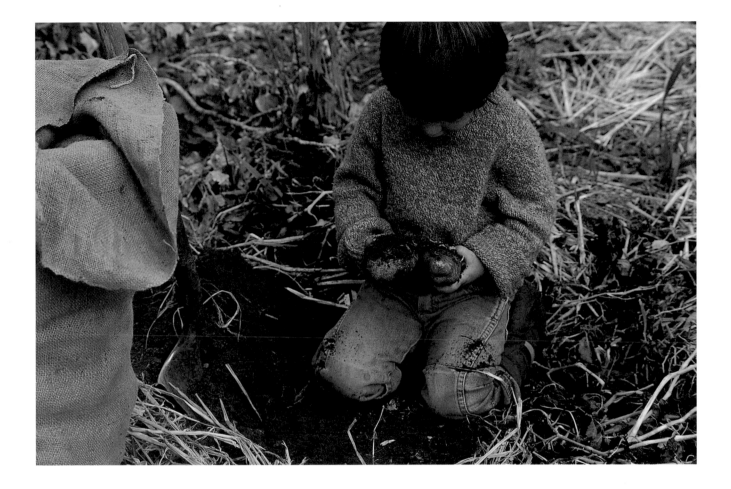

Picking Potatoes

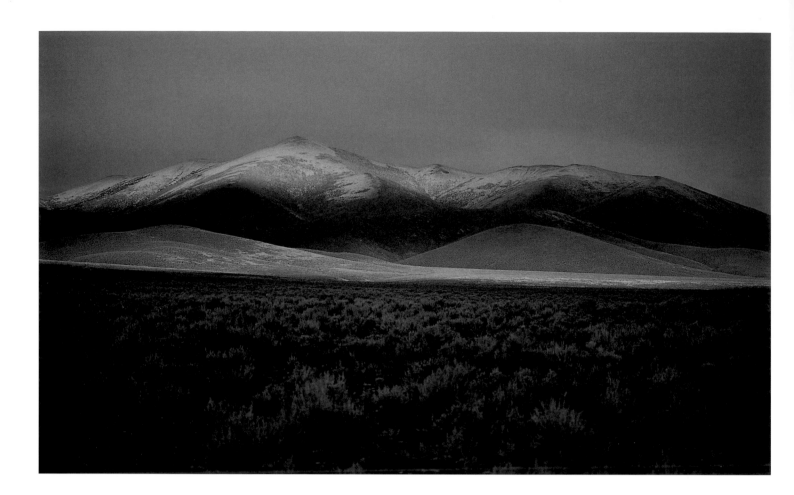

170 *Band of Light*

of this family, kept it to itself. It's a wealthy place now, but the people who built it are gone.

☼

Disaster gives a focus to people's lives, draws people together; success allows them to drift apart. We forget how much we need each other. We feel independent, secure. We leave the detritus of difficult relationships between us, allow wounds to fester, until something comes along that dwarfs all petty argument, and makes us remember that we really would not survive without each other.

The desert is a difficult environment to live in and to nurture. It will flourish, but it takes patience and knowledge of when to act, when to wait in the shade until it's time to act. Each of us is nurtured, in our own way, by the deep rhythm of the seasons on the land, the motion of light on the hills, the simple joy of a season of rain after drought. We draw a kind of sustenance from the way a sagebrush flings seed, the manic growth of its offspring in a wet winter, getting the tiny start that will bring them through the hot months of summer, when everything seems to hunker down and wait.

Most of the desert is hidden inside time. It is not possible to see it in a season, maybe not in a lifetime. The waves of plant and animal life, the way wet seasons move boulders off the mountain, give a glimpse of a much larger pattern in the fabric, moving over our circle like shadows of ripples move across the sand in shallow water. Control of this land has long since passed from the people who have cared for it. Tom's ranch was taken for wildlife refuge, the Pine Forest lands for wilderness, Alex's home place passed into the hands of wealthy men who live far away. The vast majority of

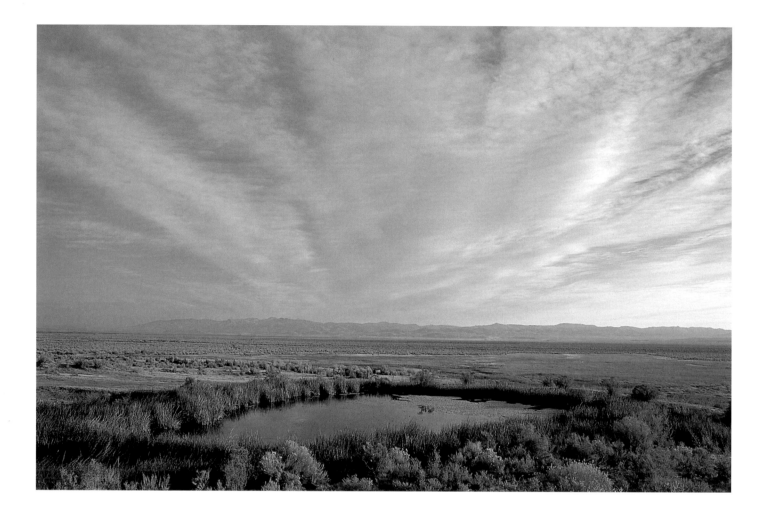

Earth and Sky

the land is public, controlled by the whim of politicians and, lately, the muscle of corporate environmentalism.

The powerful have always pushed the less powerful into history. We are a culture on the cusp of extinction, not just the ranching culture, but the culture that permits the generations to mingle, allows grandsons to work shoulder to shoulder with grandfathers. The relationship with the land has less to do with ownership than with covenant, as does the relationship between the generations. For these Basque people, a Stone Age people transplanted from ancient roots, the covenant with the new landscape is, in a sense, a continuation of the covenant with the old. The tenacious love of life and land, work and family, that they bring with them has responded to this empty place. And so the land owns us, not the other way around. We are part and parcel of the ridges and the soggy meadows, the dusty alkali and the storms that cross the emptiness. The circle of family continues, part of the landscape. The landscape feeds our circle, permits it to remain.

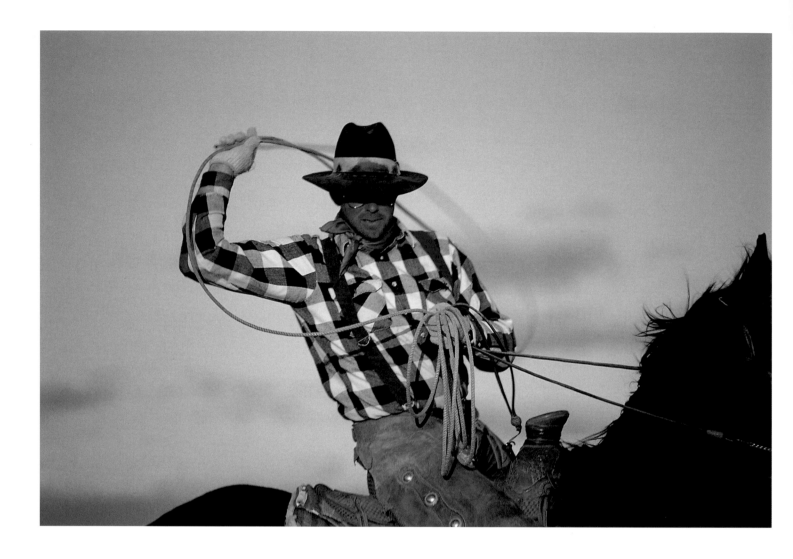

John Peter Roping

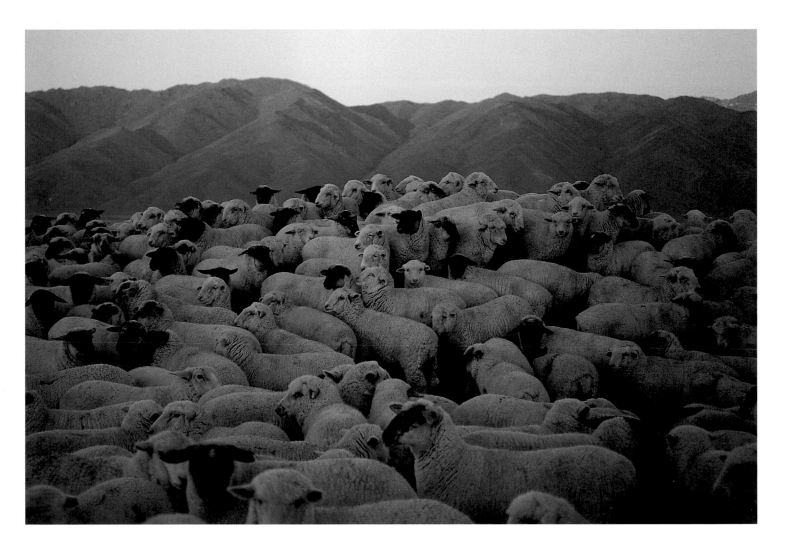

Sheep Mountain

Just a Little Peck

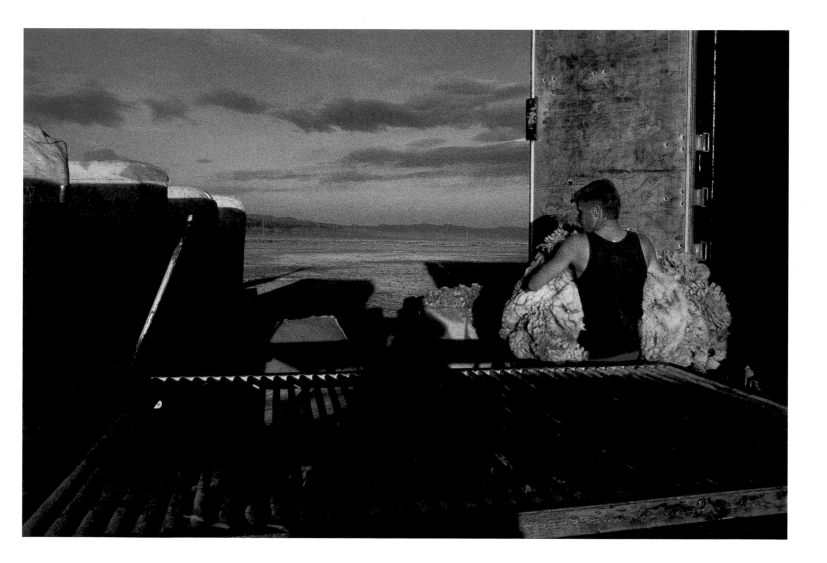

The Sheepshearer

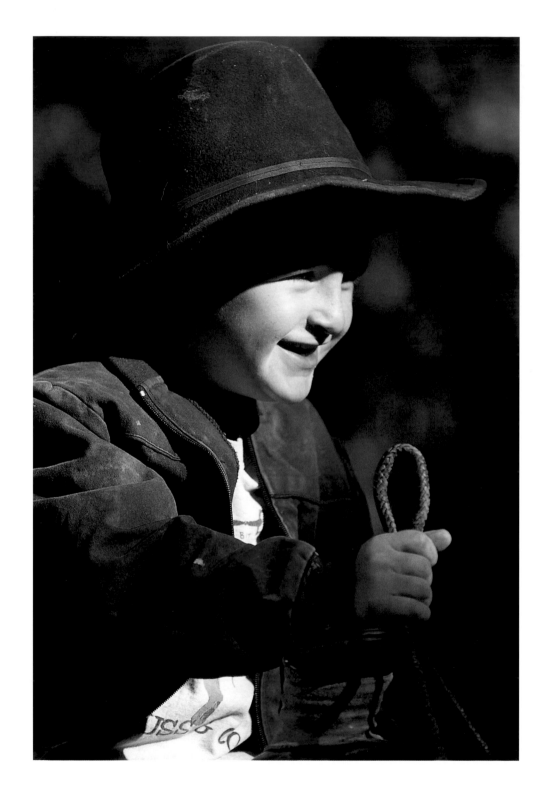

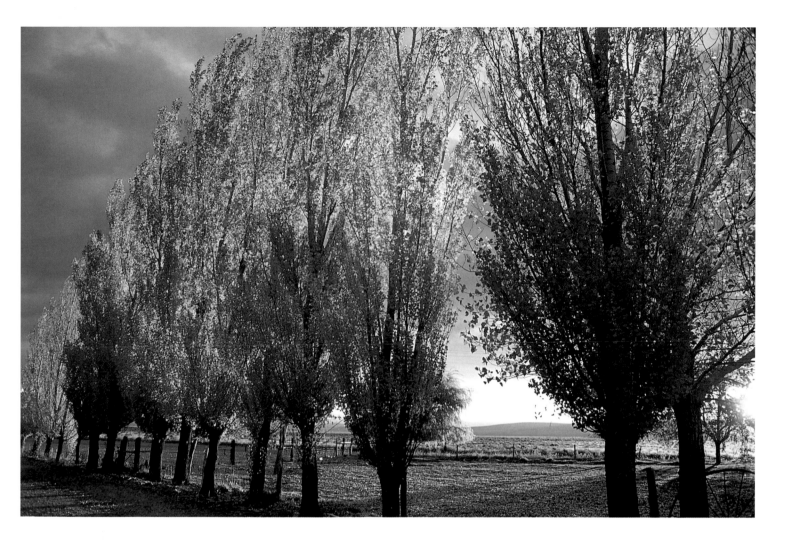

(facing page) *Little Roper*; (above) *Ranch Poplars*